Raffaello Sanzio

RAPHAEL

Raffaello Sanzio

Richard Cocke

Published in 2004 by Chaucer Press
20 Bloomsbury Street
London WC1B 3JH

© 2004 Chaucer Press

Designed and produced for Chaucer Press
by Open Door Limited
Langham, Rutland

Editing: Stephen Chumbley
Series Editor: Christopher Wright
Scanning: G.A. Graphics, Stamford, UK

Title: Raphael
ISBN: 1 904449 38 7

Printed in China

RAPHAEL

Richard Cocke

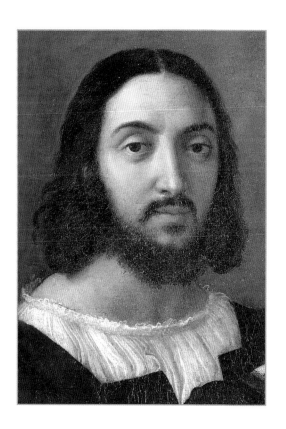

CHAUCER PRESS

CONTENTS

THE *MADONNA OF THE PINKS*

Raphael's *Madonna of the Pinks* (page 7) serves as an introduction to an artist long acknowledged as one of the cornerstones of the western tradition in painting. The Virgin, seated in a bedchamber with a view of landscape through the window, is seen in three-quarter view, as she turns to her left, with an alert active Christ Child on her lap playing with the flowers which give the painting its name, protecting him with her left hand. The figures are securely realised in space, in spite of the difficulty of their poses, all of which are secondary to their lively interplay and bonding. Although ostensibly a picture for private devotion the *Madonna of the Pinks* was much more. It was probably painted around 1507, at the end of Raphael's stay in Florence, together with the *Holy Family under the Palm Tree* and the *Bridgewater Madonna* (pages 51 and 58). The difference between these three images shows that they are significant as a 'Raphael' rather than a devotional image. The change from devotional image to self-conscious art is one aspect of the rise of the artist. For over a century humanist scholars had taken a new, higher, view of painting, sculpture and architecture, based on their study of classical texts, notably the *Natural History* of Pliny the Elder, which included a brief account of the great artists of antiquity. They did not spot that these – Apuleius in painting and Lysippus in sculpture – were associated with Alexander the Great, and so belonged to an era long past when Pliny wrote. Comparisons with these mythical artists was one of a number of factors resulting in a greatly enhanced status for painters and sculptors around 1500. For Raphael variety of invention was one of the keys to his success, chosen deliberately to distinguish himself from the older Pietro Perugino (c.1488-1524), in whose studio in Perugia he studied at the outset of his career. It was a constant in his career, a point underlined by the contrast between the *Madonna della Tenda*, the *Madonna della Sedia* and the *Alba Madonna*, painted about four or five years later (pages 130, 131 and 132).

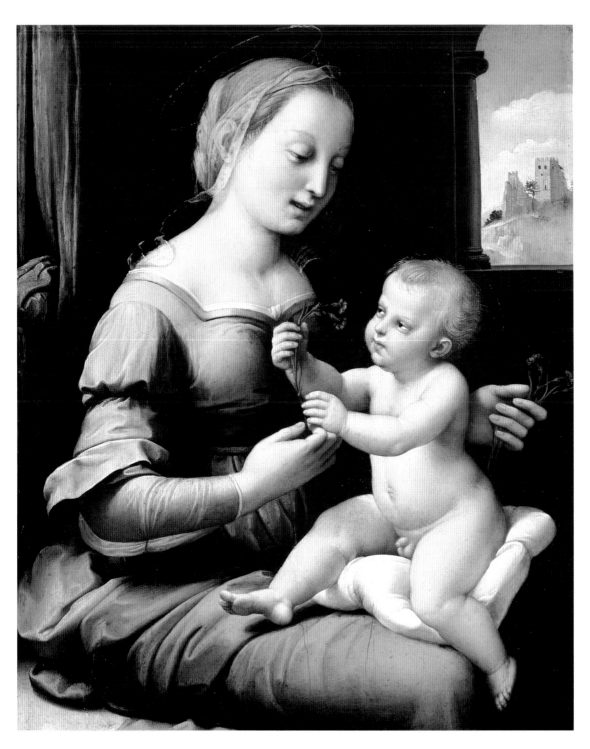

MADONNA OF THE PINKS

National Gallery, London

Oil on wood, 29 x 23 cm

The *Madonna of the Pinks* illustrates another important aspect of Raphael's work, his eclecticism. The composition and figure types were developed from Leonardo's (1452-1519) much earlier *Benois Madonna*, in the Hermitage, St Petersburg. While Raphael retains Leonardo's composition he transforms the setting, introduces a landscape and uses very different figures. This was to remain one of his fundamental achievements, notable, as discussed in Chapter One, in his earliest work where he set out to widen horizons which, for an artist born in Urbino in 1483, were limited to Umbria. His interest in the available styles prepares for his move in October 1504 to the Republic of Florence, then, as noted in Chapter Two, the artistic centre of the Renaissance as a result of Leonardo's rivalry with Michelangelo.

Florence's moment was limited. Leonardo returned to Milan, and thence to the protection of the French court, in 1506, when Michelangelo moved first to Bologna for the huge – but destroyed – statue of Julius II, and then to Rome by 1508. This was an era of huge growth for Rome. The papal household had expanded from the modest 130 under Eugenius IV (1431-47), through the 370 of Pius III in 1503, to the staggering 700 of Leo X (1513-21). This set the pattern for the cardinalatial households, whose ethos was summed up in a text of 1510 which presents the cardinal as a courtier, whose entourage only differed from that of secular rulers through the absence of women, and for whom the author recommended an annual income of 12,000 ducats. This would enable him to maintain a household of 140, necessary to uphold the dignity of his office in the style appropriate to a great prince.

This wealth found many expressions – one of the most striking, as noted in Chapter Three, was the collection of classical antiquities. On his arrival in Rome at the end of 1508 or early in 1509 Raphael studied these collections with the all-devouring intensity which he had brought to the new developments in Florence four or five years earlier. This was appropriate, as noted in Chapters Three and Four, for the historical subjects commissioned by his greatest patrons, Pope Julius II and his successor, Leo X. Rome presented the added challenge of the scale and superhuman energy

which Michelangelo created in response to the Antique in the Sistine ceiling (pages 100 and 101). Although influenced by Michelangelo, Raphael created an archeologically inspired narrative mode through a careful study of the classical sources. Not only did his art differ from Michelangelo's but so did his relationship with his patrons and his studio. Just as he distanced himself from Perugino through a sense of variety, so he ran a very different sort of workshop from Michelangelo's. Michelangelo had assistants and used helpers, but their role was subordinate, while Raphael encouraged a younger generation. Giulio Romano (1499-1546) was the most notable but far frm the only example, to help with the execution of works which Raphael designed so that modern scholars remain fascinated by the division of hands within Raphael's work.

To succeed at the court of Rome called for exceptional skills. Michelangelo, in many ways the first modern artist, followed a unique path, his genius allowing him to break the rules even in his relationship with the Pope. Raphael contributed a typically witty insight into Michelangelo's personality in the addition of Heraclitus on the steps of the *School of Athens* in the *Stanza della Segnatura* (page 70). Not included in the cartoon for the fresco, the figure resting an elbow on a block of marble and brooding over a sheet of paper is recognisably Michelangelo. Raphael presents himself as a dutiful courtier in the *Expulsion of Heliodorus from the Temple* in the *Stanza d'Eliodoro*, where he is the attendant singled out by the Pope whose chair he supports (page 82). In a world of courts Raphael was the model courtier, an example for fellow professionals.

This was one of the key lessons expounded by Giorgio Vasari (1511-74) the great historian of the Renaissance in the two editions of his *Lives of the Painters* (1550 and 1568). Whilst Raphael was established as the model for artists at court (and for Vasari there was no alternative), he did not rival Michelangelo. In Vasari's critical framework the art of his period was the final phase in a revival which had begun with Giotto and culminated with Michelangelo. Raphael/Michelangelo became a theme for many variations, beginning in Venice where partisans of Titian argued that Raphael was greater, since it was easier to compare Titian with him than with Michelangelo. In the

seventeenth and eighteenth centuries critics adjusted the comparison between Michelangelo and Raphael to accommodate accounts of later painters, whose work was seen as a return to the standards of Raphael rather than those of Michelangelo. Within the canon of Raphael criticism there were divisions over the relative weight to be given to his devotional paintings against the Roman frescoes or the tapestry cartoons.

Finally the *Madonna of the Pinks* introduces another aspect of Raphael's legacy, his significance for collectors. The seventeenth century saw a major shift in the pattern of princely collecting. Tapestries, classical sculpture and gems were still significant, but less attention was given to illuminated manuscripts as the major courts competed to build collections of 'old master painting'. The *Entombment* (page 56) stands at the head of this process; it was removed from its setting in Perugia in 1608 – just over a hundred years after it had been installed – on the orders of Pope Paul V, through whom it passed to his nephew, Cardinal Scipione Borghese, the founder of the gallery which still bears his name. Vasari's *Lives* established the corpus of great painters who should be included in any major gallery. This gave Raphael a posthumous advantage over his major rivals, Leonardo and Michelangelo, who had produced a very small number of works suitable for the market.

The history of the *Madonna of the Pinks* also illustrates the demand for major paintings by Raphael. Acquired by the 4th Duke of Northumberland in 1844, it formed the centrepiece of a 'Raphael' room at his seat in Alnwick, until downgraded in 1860 by the leading authority of the day, even though he had never seen it. Removed to a passageway and deemed a copy, it received full scholarly attention in 1992, when a combination of X-rays, cleaning and critical re-evaluation restored it to Raphael's canon of autograph works, and to display, on loan from the Dukes of Northumberland, in the National Gallery, London. When sold at auction in London it was acquired by the J. Paul Getty Museum in Santa Monica, subject to an export licence, for well in excess of £30 million. It was considered to be of outstanding importance and the export was delayed to allow the National Gallery time for an appeal – successful in this case – to purchase the *Madonna of the Pinks*. The price that the Getty Museum was prepared to pay reflects their wealth, the quality of the painting and the fact that the Museum does not possess a Raphael. By the turn of the nineteenth century his paintings had become the most sought-after works by the great American collectors, through whose efforts, and those of their successors, there are now some thirteen paintings by, or attributable to, Raphael in America. The success of the National Gallery's appeal is testimony to Rapahel and his continued relevance. To understand that we need to turn to his earliest work.

Public Commissions

Urbino was not the most promising of artistic centres for a young painter; it is true that the delle Rovere had one of the most splendid palaces in Italy, one that was still being built in Raphael's youth, and that the sparkling, intellectual conversation of the court, recorded in Castiglione's *The Book of the Courtier* published in 1528, reveals their appreciation of the Fine Arts. During Raphael's childhood the court painter, Piero della Francesca, was prevented from working by ill-health, and the gap that this left was filled with only limited success by Raphael's father who was the court painter in the period up to his death in 1494, producing a feeble version of the style of the great Umbrian artist Pietro Perugino; this would explain the touching story that Raphael's father took the boy to be apprenticed with Perugino in Perugia, unlikely since Raphael was only eleven at the time of his father's death in 1494.

The earliest datable work to survive is the double-sided standard which was painted for the church of SS. Trinità in Città di Castello, a small town which lies in the plain at the foot of the mountain pass leading to Urbino. The banner, which has been separated and which has suffered considerable paint-loss, is dated to around 1500 because on one side the two plague saints (SS. Roch and Sebastian) kneel before the Trinity, presumably in celebration of the passing of the plague in the previous year. The kneeling saints are awkward and the sparse landscape reveals a youthful awkwardness, whose eclecticism was fundamental to Raphael's subsequent development. The figures' style reflects an immature effort to assimilate the style of Pietro Perugino; the bland, almost empty heads of the two kneeling saints and that of God the Father with his beard which divides into two thick locks, are based on Perugino, as is the impressive classical meander that frames both sides of the standard. The bony, rather angular Adam from whose side God creates Eve on the reverse of the banner reveals another influence on the 17-year-old Raphael, that of Luca Signorelli (1441/50-1523), who had developed an interest in anatomy which found its fullest expression in the fresco cycle in Orvieto, on which he began work in

1499. He had worked in Città di Castello and Raphael's early drawings show his interest in Signorelli's paintings there.

Whilst eclecticism is an essential ingredient of Renaissance Art, Raphael displays a new self-consciousness that remained fundamental for his artistic make-up. In the *Healing of the Lame Man* (page 106) from the next decade, for instance, the scale and bulk of the figures rival Michelangelo, and the setting continues a Quattrocento tradition. In the period up to Raphael's visit to Florence in October 1504 the range of styles upon which he could draw was limited to the artists of Umbria; Perugino, Signorelli and Pintoricchio (c. 1454-1513) who produced a flatter, rather more decorative version of Perugino's style. Perugino's importance is underlined by the preparatory drawing for the now lost *Coronation of St. Nicholas of Tolentino* which Raphael painted for S. Agostino in Città di Castello. The commission was probably a token of his success with the banner in SS. Trinità but, presumably because he was still a minor, the contract was signed together with Evangelista di Pian di Meleto, who had worked with his father. The drawing shows St. Nicholas in the centre of the composition standing upon the vanquished figure of Satan while above crowns are held by God the Father, the Virgin and St. Augustine. Only this latter figure is recognisable from his costume, while the others are members of the workshop, wearing their studio costume.

The practice of drawing from members of the studio was one which Raphael must have learned in Perugino's workshop and his continued assimilation of Perugino's manner can be seen in the *Crucifixion with the Virgin, SS. Jerome, Mary Magdalen and John the Baptist* in the National Gallery, London (page 15), which was originally painted for a chapel in S. Domenico, Città di Castello, probably in c. 1502-03, the date by which the chapel was completed. All the elements in the painting, the poses of the kneeling figures, the languid contrapposto of the Virgin and of St. John and the

articulation of Christ with its emphasis upon the contours of the figure, show his debt to Perugino; the kneeling figures are now more convincing than in the earlier banner and the expansive landscape leading back to the horizon where the blue of the sky is modulated by the white clouds proclaims his successful assimilation of the formula that Perugino had adopted from Flemish painting. The painting is limited by the stereotyped expressions of the saints who fail to communicate grief or concern. The composition anticipates his great achievement in the Stanze for the round-headed shape of the altar is reflected both in the curves that run through the flying angels and in that which leads from the Virgin's right foot through the legs of the kneeling St. Jerome and those of the Magdalen to the St. John on the opposite side.

His skill finds a different expression in the *Coronation of the Virgin* (page 16) in the Pinacoteca Vaticana, Rome which was painted for S. Francesco, Perugia, probably at the same time as the Crucifixion, in c. 1502-03. The picture is clearly divided into two halves which reflect the division of the original frame: in the lower the Apostles stand around the empty sarcophagus which is filled with roses (the symbol of Christian martyrs) and lilies of the valley (the symbol of angels and virgins), and in the upper the Virgin seated on the clouds that divide the painting bows forward to receive the crown from Christ. In the absence of any documentary evidence it is unclear why Raphael chose to combine the *Coronation of the Virgin* with her *Assumption*; this may have been called for in the contract or it may be the first example of the freedom with which Raphael manipulated and changed the subject-matter of his commissions, a freedom which we find again in the *Entombment* (page 56) and the *Transfiguration.* (page 160) Raphael took enormous care with the composition; the heads of the Apostles are aligned and reinforced by the landscape background. He contrasted the poses of the two Apostles who frame the composition at either side, their gestures achieving an eloquence denied to their features but even here Raphael has taken care to vary the angle at which they look up in response to the Coronation where the angels are positioned to give what would otherwise be a rather linear composition a depth that echoes that of the lower part of the panel.

CRUCIFIXION WITH
THE VIRGIN SS. JEROME,
MARY MAGDALEN
AND JOHN THE BAPTIST
National Gallery, London
Oil on wood, 280 x 165 cm

We can bring out Raphael's skill by comparing the lower part of his panel with his model, the *Assumption of the Virgin* by Pintoricchio in Santa Maria del Popolo, Rome, painted in the 1490s; Pintoricchio's figures are flat and insubstantial and their relationship with the sarcophagus is unconvincing. The surviving drawings for the composition record the care that Raphael took with expressions and gestures which are more eloquent than those of Pintoricchio as Raphael 'improved' upon his model, although clearly impressed by the elegance of Pintoricchio's style in the Virgin. Our recognition of Raphael's superiority over Pintoricchio is not simply a matter of hindsight; according to Vasari, when in 1503 Pintoricchio received the commission for the cycle of frescoes celebrating the life of the Sienese Pope, Aeneas Sylvius Piccolomini, Pope Pius II, he asked Raphael to assist him with drawings and cartoons. Vasari's account is borne out by a series of drawings and cartoons for the frescoes in the Piccolomini Library in Siena Cathedral. Modern scholars agree that they are by Raphael since the *Study of Horsemen* (page 30), one of the series now in the Uffizi discussed in the next chapter, displays a solidity and depth lacking in the frescoes, in whose execution Raphael played no part.

PRIVATE COMMISSIONS

The Coronation was completed by three predella panels with scenes from the life of the Virgin, the *Annunciation*, the *Presentation in the Temple* and the *Adoration of the Magi* which, although prepared with the same care were slighter and sketchier in style in contrast, not only with the main panel, but also with other small panels that Raphael produced for noble patrons. These include the *Vision of a Knight* now in the National Gallery, London, and its companion, the *Three Graces,* in the Musée Condé in Chantilly. The knight lies asleep on the ground under a tree that divides the landscape. In his dream he has to choose between the steep path of virtue on the left of the panel with the lady who offers him a sword and a book, and the simpler path of pleasure on the right with the lady in richer costume who offers him a flower. The imagery derives from classical accounts of the Roman general Scipio Africanus and this, together with the fact that, together with its companion, it was long in the Borghese collection have suggested that it was commissioned to help educate Scipione di Tommaso di Borghese, born in Siena in 1493, to a life of virtue, in spite of the charms of the companion *Three Graces*, either a diptych with or on the reverse of the *Vision of a Knight*. The *Three Graces* are based upon a famous classical marble which had been in Rome in the latter years of the fifteenth century, but which Cardinal Piccolomini had sent to Siena in 1502, where Raphael would presumably have seen it while preparing drawings for Pintoricchio. The group had already influenced Renaissance medallists but the skill with which the poses of the figures are balanced shows that Raphael returned to the original although the later versions helped him to reconstruct their arms and heads, which are missing from the group in Siena.

OVERLEAF

LEFT: VISION OF A KNIGHT
National Gallery, London
Oil on Wood, 17 x 17 cm

RIGHT: THREE GRACES
Musée Condé, Chantilly
Oil on wood, 17 x 17 cm

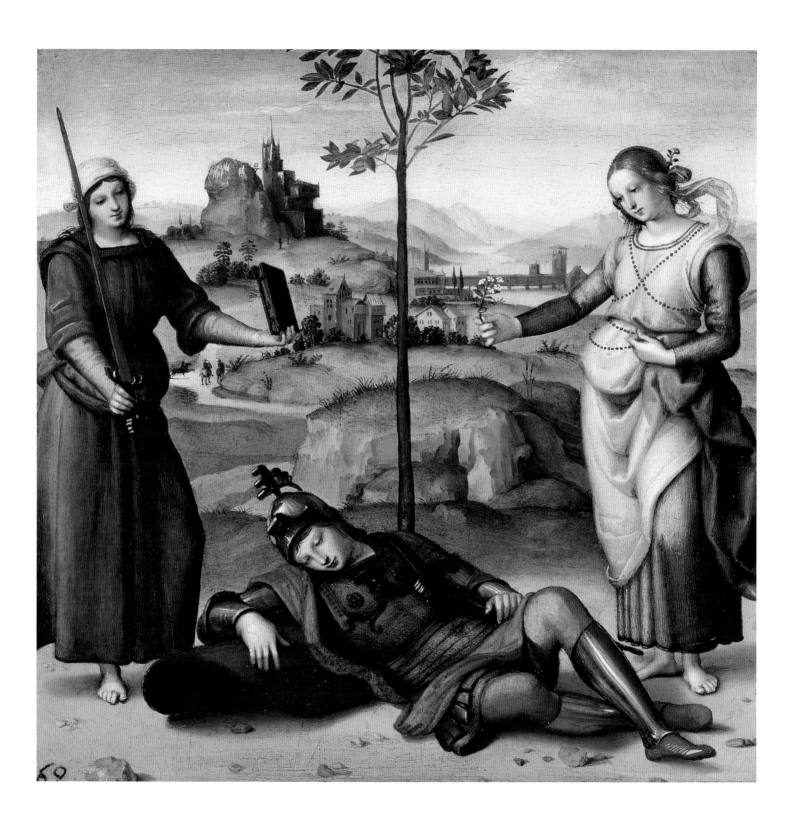

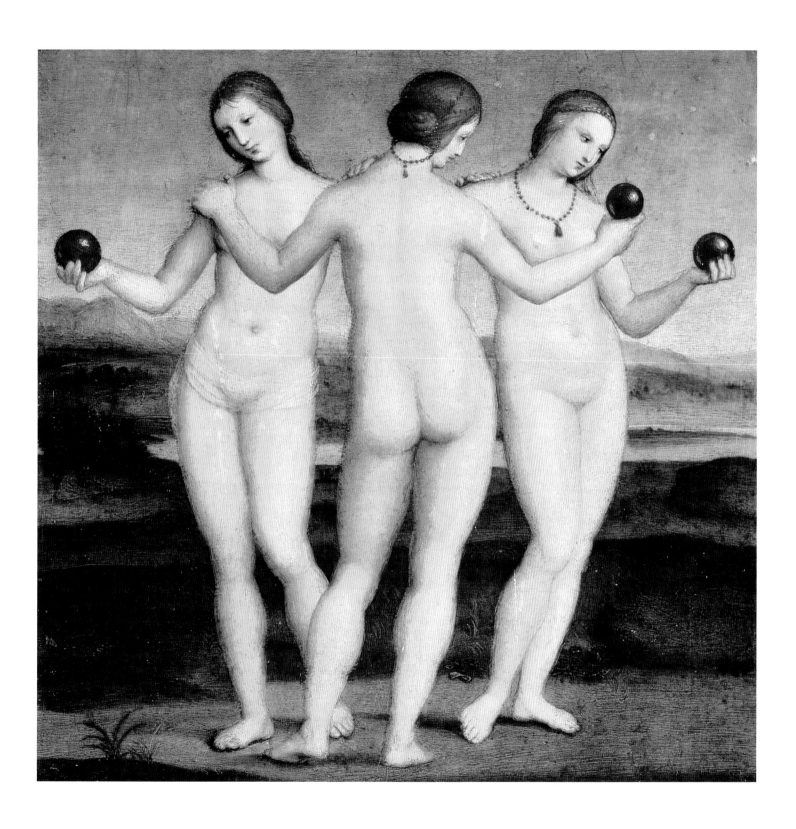

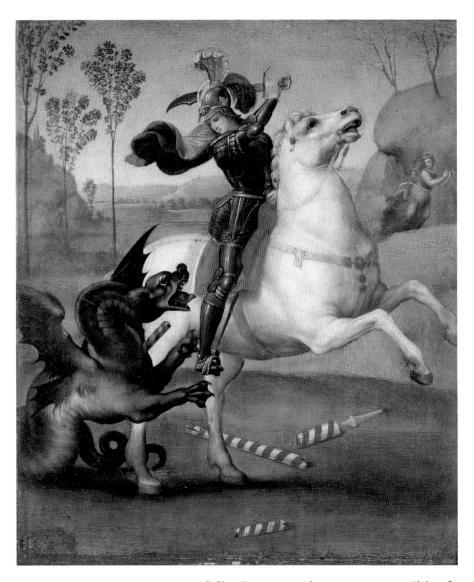

St. George

Musée du Louvre, Paris

Oil on wood, 31 x 27 cm

Right: Detail of St George

Far Right: St. Michael

Musée du Louvre, Paris,

Oil on wood, 31 x 27 cm

The *Three Graces* is not the only example of Raphael's knowledge of the Antique in this pre-Florentine period; the monumental, elongated neck of the horse that St. George rides in the small panel now in the Louvre, Paris clearly derives from the colossal horses which, together with their horse-tamers, were one of the sights of Rome on Montecavallo. The picture made up a diptych with the *St. Michael* where the Archangel gracefully treads underfoot a demon while the background is filled with damned figures and monsters that clearly reveal Raphael's appreciation of the grotesque art of Hieronymus Bosch, some of which he had presumably seen at the court of Urbino. The early history of these paintings is uncertain. It is tempting to follow the suggestion that they may have been painted for Giovanna Felicia Feltria della Rovere (who was responsible for Raphael's letter of introduction to the Gonfaloniere of Florence in October 1504). Her father and brother were both honoured with the Order of the Garter (for whom therefore St. George the patron saint of England would be extremely suitable) and whose husband and one of her sons received the Ordre de Saint-Michel in 1502-03; she returned to Urbino in June 1504 and the picture may date from this period before Raphael's visit to Florence.

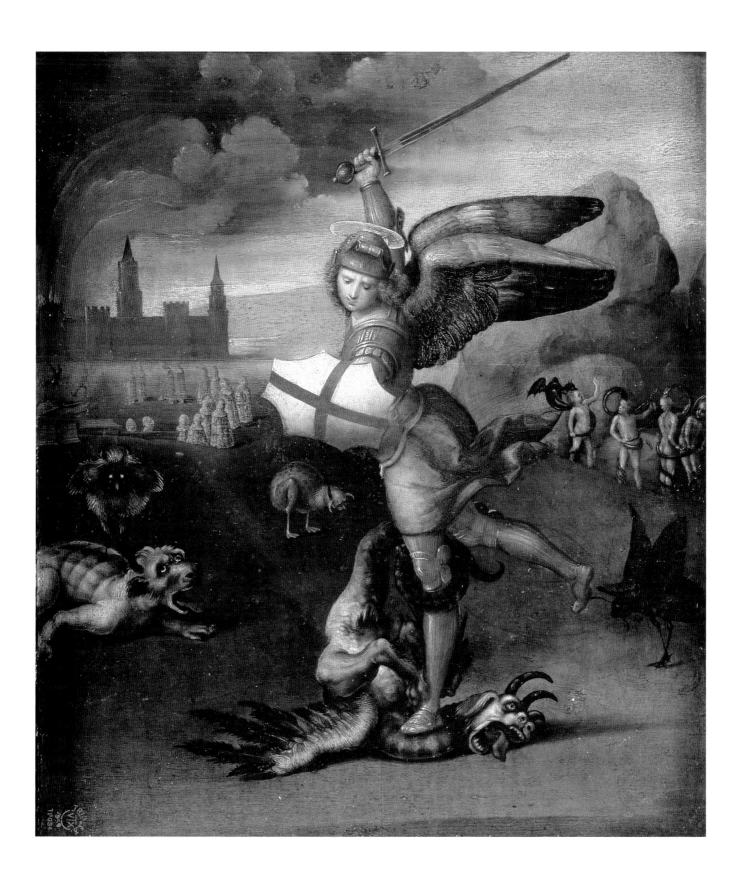

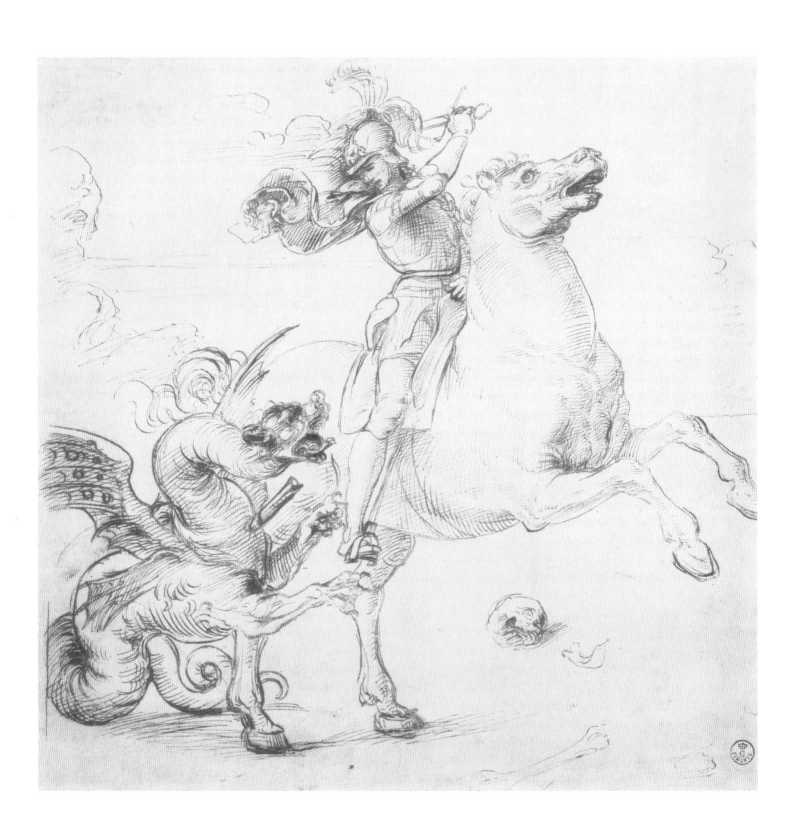

Raphael himself painted a second version of the St. George in the National Gallery, Washington, which is signed on the horse's breast-strap and in which St. George wears the Order of the Garter with its inscription 'HONI' on his left leg. Rider and horse fit into the landscape with greater skill; the diagonal line of the hill on the left continues through the horse's back and the group of rearing horse and fallen dragon are linked together more successfully by St. George's lance which echoes the line of his left leg. The landscape is of a type that he had clearly learned from Perugino, but it is more fully realised than in the Louvre version and also includes an echo of Rome in the *Torre della Milizia* which is shown on the horizon just above the horse's head. In 1504 King Henry VII of England had elected Duke Guidobaldo delle Rovere to the Order of the Garter, partially in the hope that he would help with his own political aims, and in February 1505 the court of Urbino planned to send Castiglione to London to receive the insignia on the Duke's behalf; Castiglione was to take with him a St. George by Raphael, together with a gift of the best available horses, and although many scholars believe that it was the Louvre version that was sent to Henry, the inclusion of the garter in the Washington panel together, with the fact that the Paris picture has long formed a diptych with the *St. Michael* make it reasonably certain that it was the Washington panel that accompanied Castiglione to London in October 1505.

These small paintings all reveal, as we have seen, evidence of Raphael's growing interest in the Antique and some of the motifs that he quotes only occur in Rome. To this evidence can be added more, based upon drawings that do not relate to surviving paintings. In spite of the impressive amount of detail that can be accumulated, it is unlikely that Raphael made a visit to Rome in the years before his move to the city sometime at the end of 1508 or the beginning of 1509. Raphael's documented Roman work reveals an appreciation of the scale and grandeur of free-standing classical statuary that is not present in any of the works already discussed; some notable discoveries were made in the intervening period. Much of the sculpture that so impressed him later was already in Rome and it can be assumed that his use of classical quotations shows that he had access to a sketchbook recording some of the sights of Rome.

LEFT: CARTOON FOR ST. GEORGE AND THE DRAGON Gallerie degli Uffizi, Florence *Pen over traces of black chalk, pricked for transfer, 26.5 x 26.7 cm*

Public Commissions

The *Marriage of the Virgin*

Working from earlier sketches was a well-established studio practice and one that can certainly be traced in the outstanding altar that Raphael produced in the period before his visit to Florence, the *Marriage of the Virgin*, now in the Brera but painted for the church of San Francesco in Città di Castello in 1504. According to an old but popular legend, the Virgin became a ward of the Temple and at the age of fourteen had to marry, against her wishes; with divine intervention all the men of the house of Jesse had to take wands and one sprouted to indicate her future husband, Joseph. Under the careful scrutiny of the High Priest, he places the ring on the hand of his bride, who is accompanied by attendants, presumably from the Temple. The unsuccessful suitors are on Joseph's side; the foreground figures fill the front of the panel right to the edges but the movement from the leading attendant on the left through the central group and out again to the angry young suitor breaking his wand in disgust gives this simple composition balance and interest.

Raphael here reworked Perugino's altar of the same subject painted for the Duomo, Perugia, from 1499-1504, itself adapted from Perugino's earlier fresco in the Sistine Chapel. The round centralised Temple of Jerusalem, with an Ionic colonnade whose volutes connect with the great drum supporting the dome, was based on a drawing by the Sienese architect Francesco di Giorgio (1439-1501/2), from the earlier of his two treatises on architecture, now in Turin. Francesco di Giorgio had worked at Urbino, where no doubt Raphael had seen his manuscript, which was also to influence Bramante (1444-1514) in the design of a classical martyrium for St. Peter, the *Tempietto* in S. Pietro in Montorio in Rome. Raphael was equally inventive in his adaptation of Perugino's figure-style, injected with with greater vigour. He had gone as far as possible within the confines of his native Urbino, and was ready for the challenge of Florence.

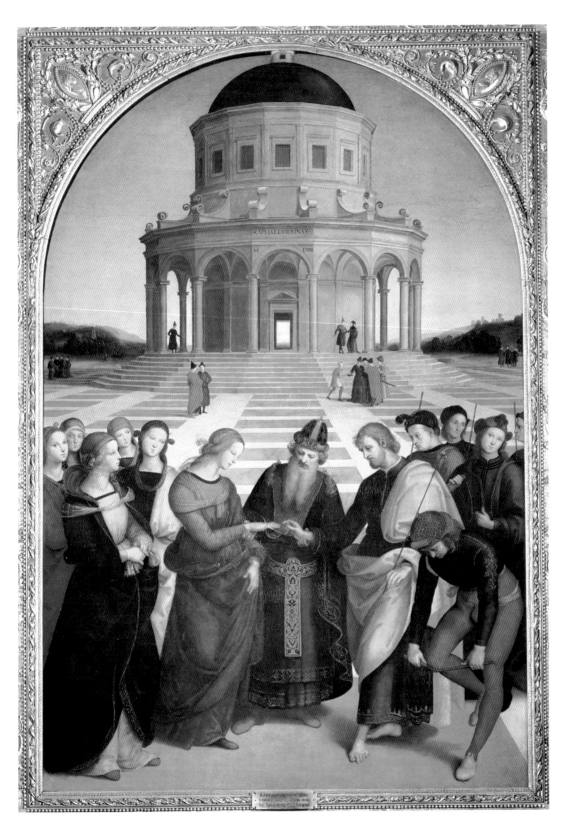

MARRIAGE OF THE VIRGIN,

DATED 1504

Brera, Milan

Oil on wood, 170 x 118 cm

THE IMPACT OF LEONARDO AND MICHELANGELO

In October 1504, the year in which Raphael signed and dated the *Marriage of the Virgin*, he received from Giovanna Felicia Feltria della Rovere a letter of recommendation to Pietro Soderini, the Gonfaloniere of Florence. During the following four years Raphael travelled between Perugia, Urbino and Florence but Florence offered a new range of artistic possibilities that enabled him to transcend the limited Umbrian style of his early works. This was in some measure due to Soderini's position as the leader of the relatively short-lived Republic, which followed the expulsion of the Medici in 1493. Soderini was responsible for the commission to Leonardo da Vinci (1452-1519) and his younger rival Michelangelo (1475-1564), for their large-scale patriotic battle-scenes for a wall of the new council-chamber in the Palazzo Vecchio. The combination of scale, artistic rivalry and the patriotic image of the Republic lead to a new classicism. in both frescoes, neither of which were completed,which can be judged through descriptions, copies and preparatory drawings.

In the *Battle of Anghiari* Leonardo sought to revitalise an older tradition of history painting by linking the individual combatants together into tightly-knit groups where the action and expression was greatly intensified. In the *Battle of Cascina* Michelangelo caught the confusion of a group of soldiers bathing in a variety of complex poses who are warned by their captain of the danger before the arrival of the enemy. Both Leonardo and Michelangelo made use of the Antique; many of Michelangelo's figures were inspired reworkings of the Torso Belvedere that he had seen on his visits to Rome while the melée of leaping horsemen and fallen soldiers in Leonardo's cartoon reflects his study of classical battle sarcophagi.

RIGHT: STUDY OF DAVID,
AFTER MICHELANGELO
British Museum, London
Pen and ink on paper,
39.3 x 21.9 cm

While this commission was the latest sight in Florence, Raphael's drawings show that he was interested in much more, including Donatello's St. George in San Michele of about 1415, the cartoon of the *Virgin and Child with St. Anne* that Leonardo had displayed to such effect upon his return to Florence in 1500 (which is not to be confused with the later cartoon now in the National Gallery, London), his *Leda and the Swan* as well as the portrait of *Mona Lisa*. Raphael's drawing style shows that he studied Leonardo's drawings with their curved parallel hatching lines that model form with great plasticity and bulk. He learned from Michelangelo with similar avidity, drawing models in the studio in the pose of the *David*, making rapid sketches from memory of the Virgin and Child in Michelangelo's *Taddei Tondo*, in the Royal Academy, and of the *St. Matthew* which was blocked out for the Duomo.

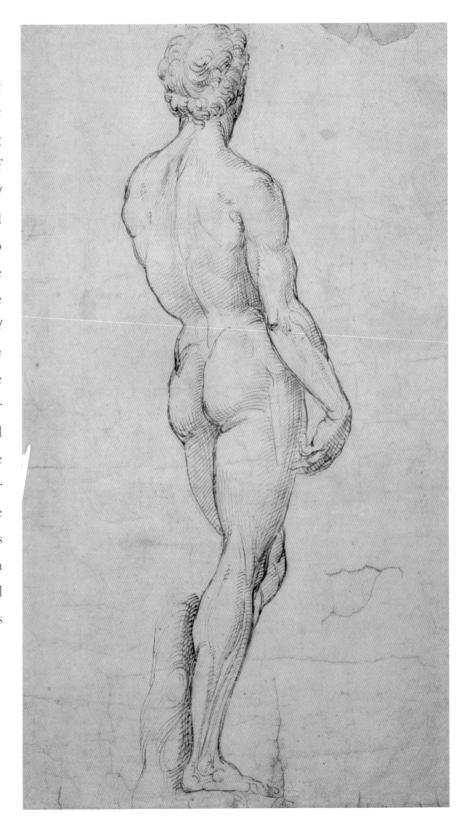

RIGHT: STUDIES OF THE

VIRGIN AND CHILD

British Museum, London

Pen over traces of red chalk,

25.4 x18.4 cm

STUDY FOR THE MADONNA

OF THE MEADOW

Albertina, Vienna Bd IV

Pen over stylus, 36.2 x 24.5 cm

RAPHAEL AS DRAUGHTSMAN

Already in Urbino Raphael had inherited the Florentine approach to drawing, fully developed by Antonio Pollaiuolo (c. 1432-98). Pollaiuolo established his compositions with rapid pen and ink sketches, which he followed with detailed studies of models in the studio, before combining these stages in *modelli* (finished drawings the size of a standard sheet of paper) for the whole design. These were then were expanded and transferred to a cartoon the same size as the final panel or fresco. This in turn was transferred either by being pricked so that fine charcoal could be dusted through or by having black chalk rubbed on the back and the main lines gone over in stylus.

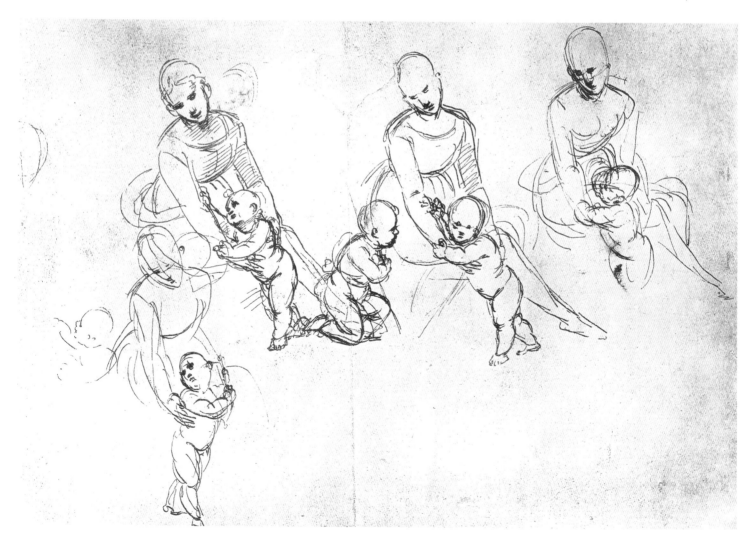

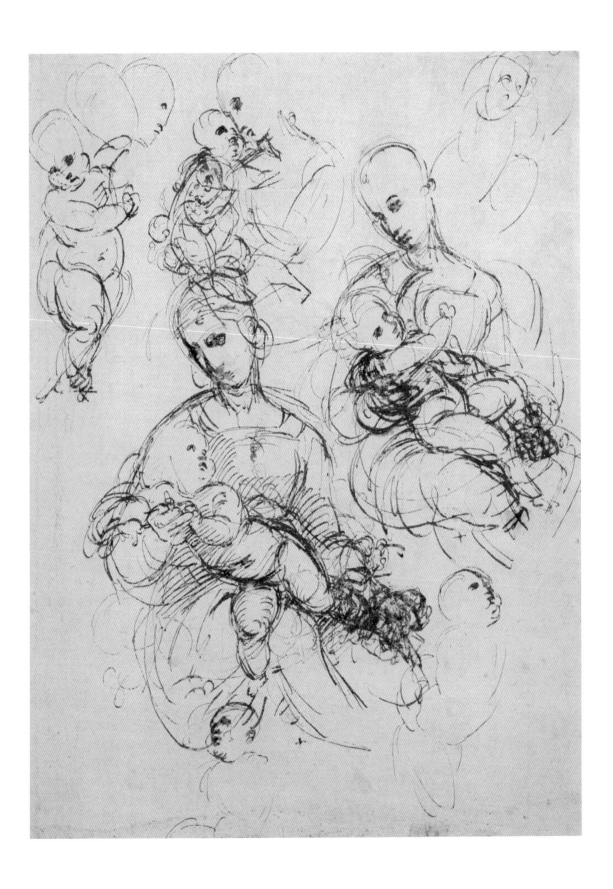

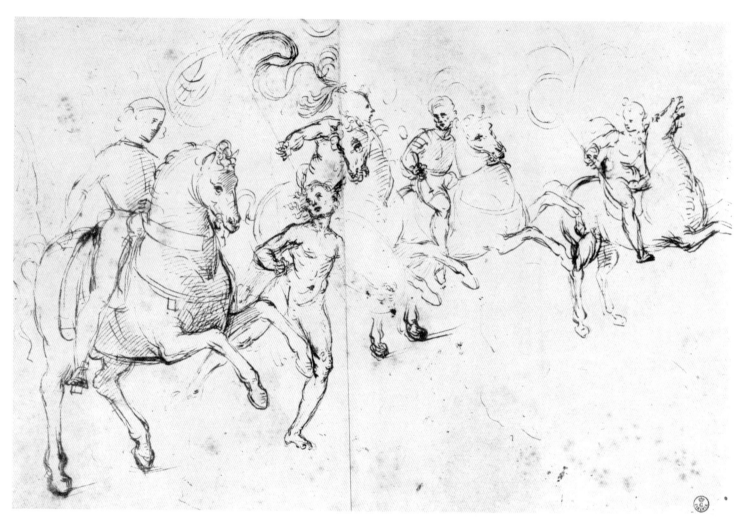

STUDY OF HORSEMEN

Gallerie degli Uffizi, Florence

Pen over stylus, 27.2 x 40 cm

Perugino had adapted this procedure, which Raphael had mastered before his arrival in Florence, as can be seen from the *Preparatory Drawing for the Coronation of St. Nicholas of Tolentino*. Although later, Raphael's beautiful study for the *Madonna of the Meadow* reflects this tradition in its spare use of the pen and searching variations on what seems in the completed painting the most natural of compositions. Leonardo had transformed this class of invention sketches, where each figure and line is established with relative clarity, allowing the changing pen strokes (the pentimenti) to serve as fresh inspiration. Raphael developed this new inventive drawing style in, for example, the *Studies of the Virgin and Child* where he moves from the the splurge of the pen strokes to studies for two paintings, the *Bridgewater Madonna* (page 58) in Edinburgh, and the *Colonna* in Berlin.

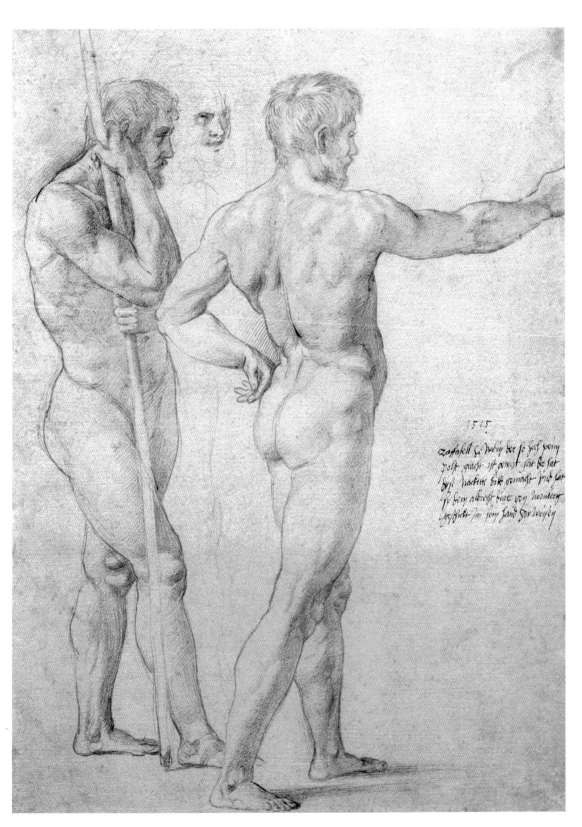

TWO STANDING NUDES

Albertina, Vienna

Red chalk over stylus,

40.3 x 28.1 cm

Inscription in pen

by Albrecht Dürer

MASSACRE OF THE INNOCENTS

British Museum, London

Pen and ink over red chalk,

23.2 x 37.7 cm

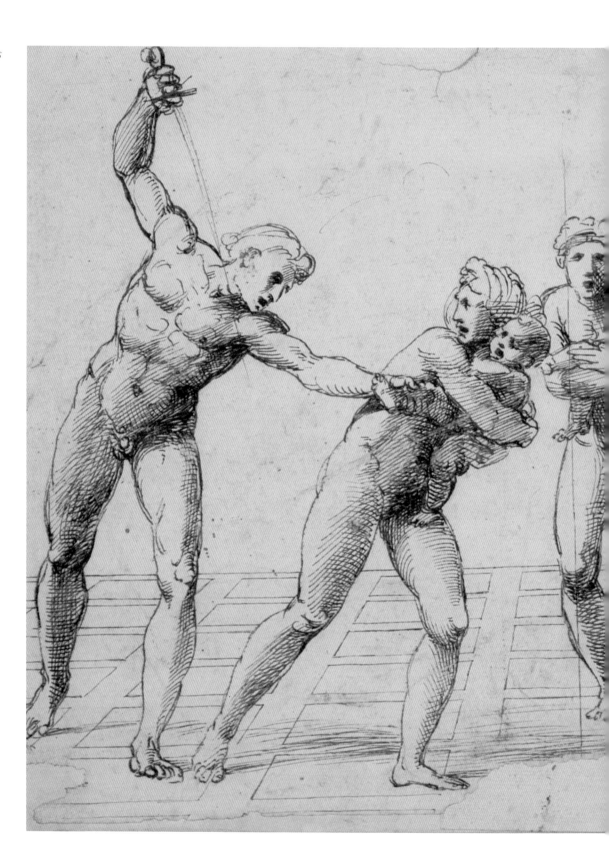

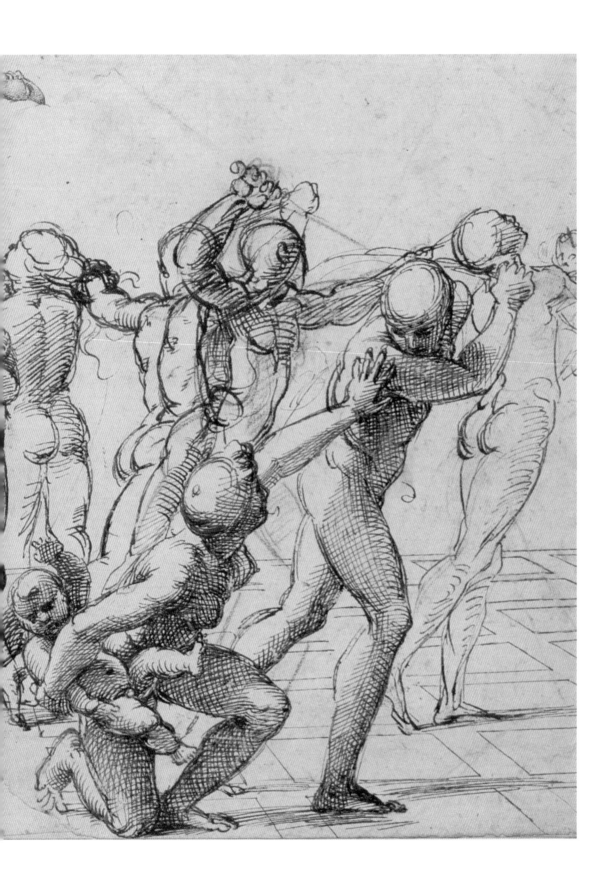

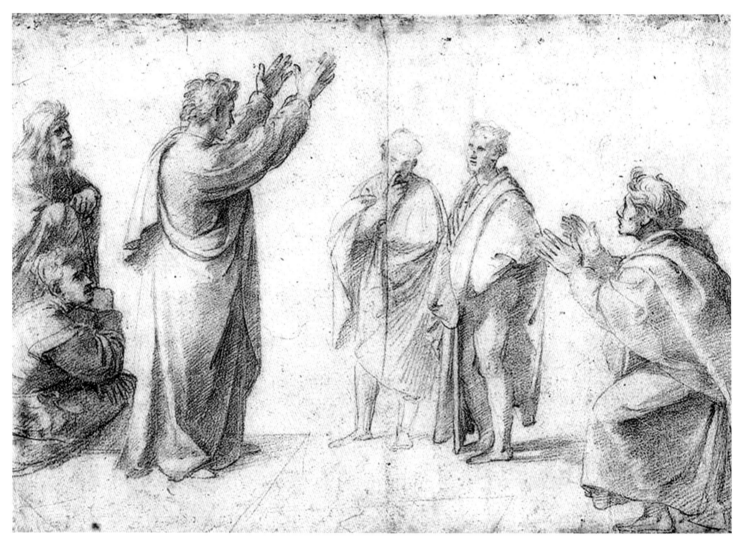

Study for St. Paul

Preaching at Athens

Gallerie degli Uffizi, Florence

Red chalk over stylus,

22.8 x 10.3 cm

Raphael's drawings had been held in high esteem from early in his career, for example a group which he provided to his older contemporary, Pintoricchio, as noted in the previous chapter. In the pen and ink study of horsemen in the Uffizi, Florence Raphael achieves a new energetic movement in the rearing horses, whose lively certainty echoes the Louvre and Washington versions of the *St. George*.

The energy is further conveyed in the man running alongside the leaping horse and the rider on the next horse whose shout is Leonardoesque, all of which was unsuitable for the dignified cortège of the fresco. The man running between the horses

represents Raphael,s study of the nude in Florence. His drawings ranged from individual studies, like that of the model posed as Michelangelo,s David, to groups of fighting men. These were worked out in pen and ink, a medium which conveyed energy and movement, and which Raphael used for the *Massacre of the Innocents*, prepared soon after his arrival in Rome, whilst working on the *Flaying of Marsyas* on the ceiling of the Stanza della Segnatura, for the engraver Marcantonio Raimondi (147/80-1534). In the study in the British Museum Raphael combined his characteristic bold outline with an energetic hatching, to suggest movement and monumentality, derived from the study of classical statuary. The British Museum drawing was developed in a red chalk study, now in the Royal collection, Windsor, since pen and ink had come under scrutiny as Leonardo and Michelangelo exploited the flexible medium of chalk for a finer description of texture and the play of light, illustrated in Raphael,s *Two Standing Nudes*. The supple chalk suggests the detailed musculature and allows a strong contrast between highlight and shadow.

Raphael,s concern for texture led him to the occasional use of silverpoint on prepared ground, in the *Study of the Left Hand side of the School of Athens*, for example. This older technique required absolute certainty of hand, through which Raphael suggests the play of light on the members of the workshop, grouped as in the fresco, with the standing figure sketched again on the right of the sheet, in a pose and costume which comes closer to the fresco. For another similar study of members of his workshop, the *Study for St Paul Preaching at Athens*, with cloaks thrown over their everyday costume to block out the effect of raising St Paul on steps Raphael exploited the relatively soft-grained chalk to establish a very real sense of the play of light and shade. In a comparable composition study for the *Freeing of St. Peter* in the *Stanza d'Eliodoro* he turned to pen, wash and white heightening for a night scene with a variety of light-sources, all of which were secondary to that of the angelic light in the centre. In the fresco the composition was modified with larger blocks of masonry, the addition of the moon and a torch, and larger, more energetic flanking figures.

Study for the Freeing of St. Peter

Gallerie degli Uffizi, Florence

Pen, brush and white heightening,

25.7 x 41.5 cm

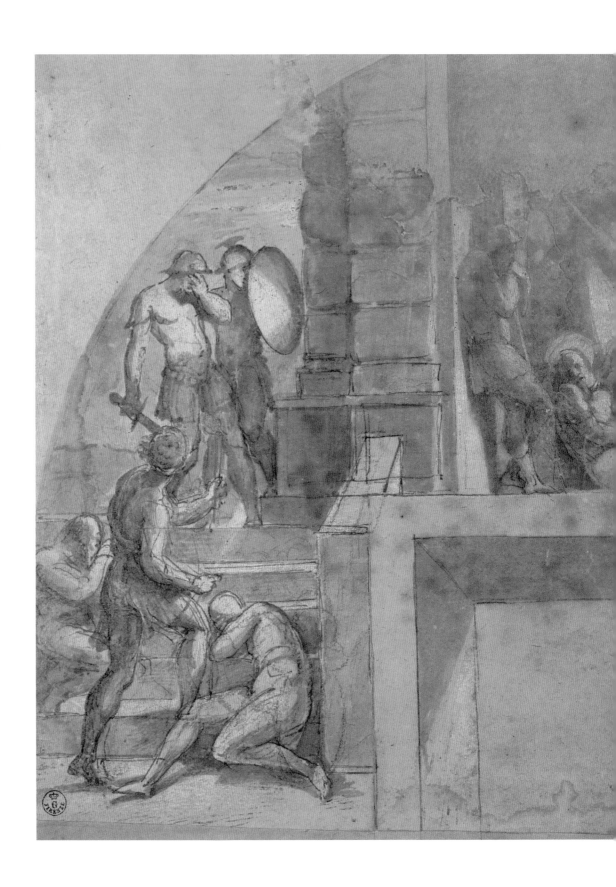

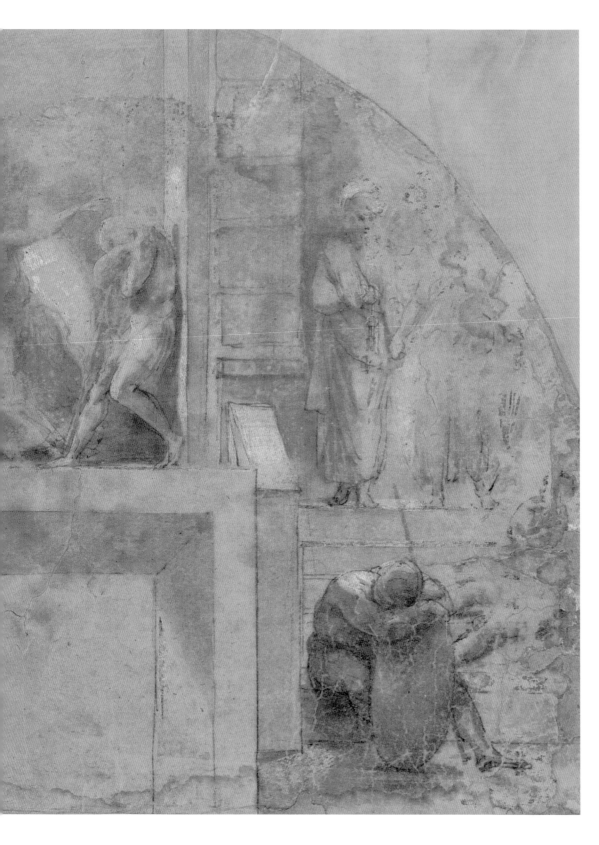

Overleaf: Modello for

the Entombment

Gallerie degli Uffizi, Florence

Pen over traces of chalk, squared,

28.9 x 28.9 cm

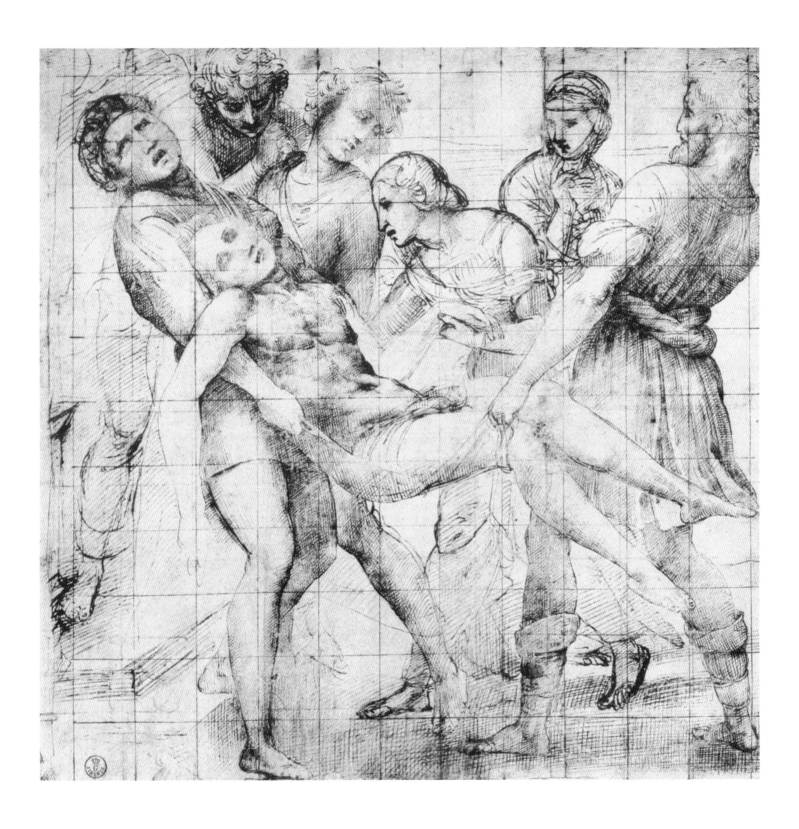

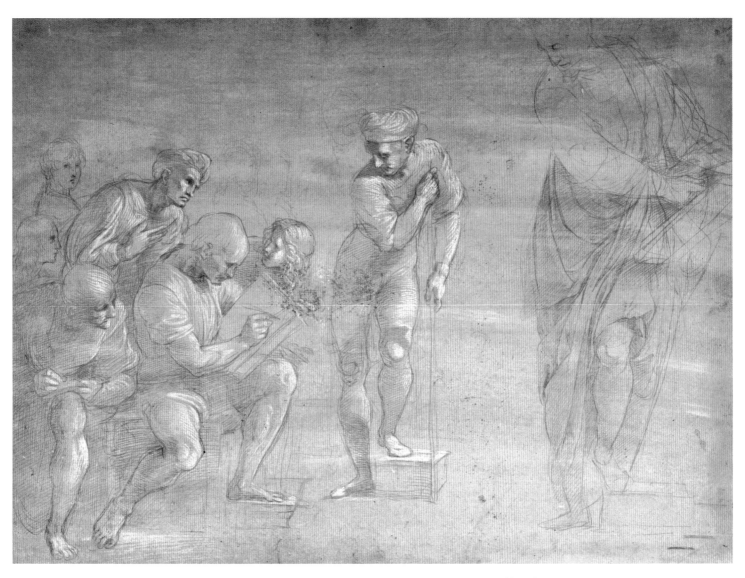

That drawing would have been followed by a detailed modello, like that in the Uffizi for the *Entombment*, which is squared for transfer to a cartoon. The striking cross-hatching unifies the composition, but fails to suggest the range of textures found in late comparable drawings. Even at this stage in what had been a lengthy process Raphael continued to change the composition in the final painting, where he removed the mourning woman second from the right to the group supporting the fainting Virgin, and simplified the distracting mass of legs under Christ. The final, cartoon, stage is

STUDY FOR THE LEFT SIDE OF

SCHOOL OF ATHENS

Albertina, Vienna

Silverpoint and white heightening,

28.9 x 39.7 cm

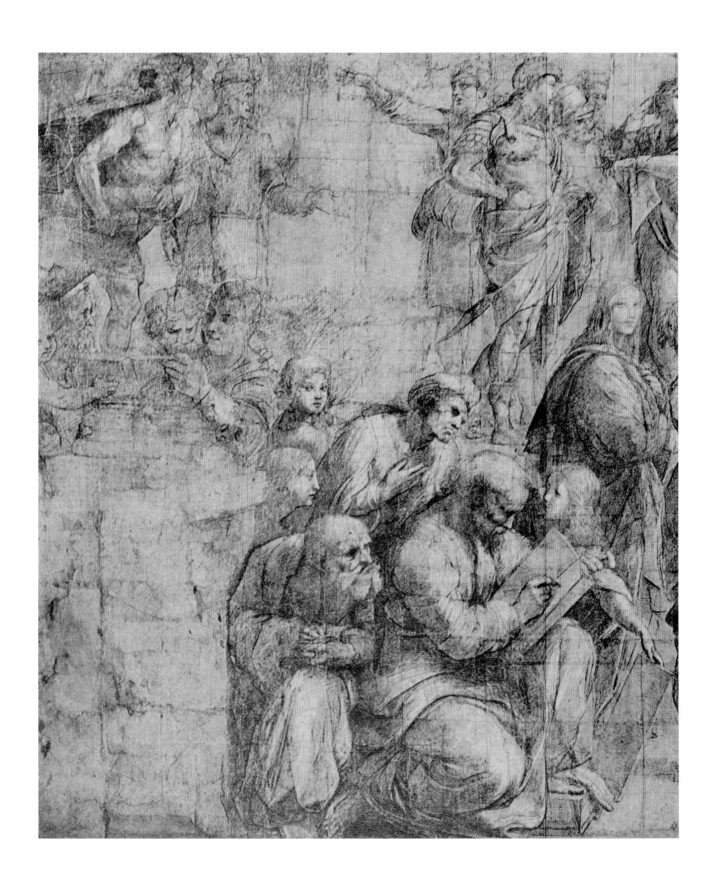

represented by that for the *School of Athens* in the Ambrosiana, Milan, although some
fragments of others survive, a testimony to the considerable enthusiasm for Raphael's
drawings; just as the fresco reveals a carefully-considered debt to Leonardo so does
the drawing of the grey chalk on the warm brown, which strongly suggests the
example of Leonardo's cartoons. These, however, had become works of art in their
own right, rather than a means to an end and the scale and intensity of the task
involved in producing this great cartoon meant that artists had to find other, more
efficient, ways of transferring their designs to canvas or wall.

LEFT: SCHOOL OF ATHENS,
DETAIL FROM THE CARTOON,
1510-1511
Biblioteca Ambrosiana,
Milan, Italy
Pencil and chalk on paper,
280 x 800 cm

First Florentine Commissions

Whist studying in Florence Raphael retained contacts in Umbria, resulting in the
commission from Bernardo Ansidei for the *Virgin and Child Enthroned with SS. John
the Baptist and Nicholas of Bari*, in the National Gallery, London, for S. Fiorenzo,
Perugia in 1505. At first the intense study of recent Florentine art had little immediate
impact, for the National Gallery altarpiece fits with an Umbrian tradition of
enthroned *Holy Families* with a view of landscape between the throne and the framing
piers; the Virgin and St. John are still Peruginesque in type while the bulkier, massive
St. Nicholas echoes the more monumental style of Signorelli. The fresco of the *Trinity
with SS. Benedict, Placidus, Maurus, Romualdus, Benedict the Martyr and John the
Martyr* in San Severo, Perugia, which is dated to 1505 by an inscription and which
was later completed by Perugino, has a Florentine model for its composition, either
Ghirlandaio's fresco of the *Coronation of the Virgin* on the altar wall of S.M. Novella,
Florence, completed by 1490 or the later *Last Judgement* by Fra Bartolommeo, which
was itself influenced by the Ghirlandaio. The fresco, which is in poor condition
having almost completely lost the figure of God the Father above Christ, showed a
theme that was then enjoying something of a vogue, a group of saints adoring the
Trinity. In spite of Raphael's efforts to contrast the profile and full-face views of the
saints the effect is rather stiff, both in their drapery and in the recession

VIRGIN AND CHILD
ENTHRONED WITH SS. JOHN
THE BAPTIST AND NICHOLAS
OF BARI

National Gallery, London

Oil on wood, 209 x 148 cm

backwards with one figure set behind the next in an almost straight line. One of the drawings for the fresco, in the Ashmolean Museum, Oxford, shows rapid sketches after Leonardo and the drawing for St. Maurus is fully Leonardoesque with an expressive downward curl to the edges of the saint's mouth which is not carried through so successfully in the fresco.

We can gauge Raphael's response to Florentine art in the portraits of Agnolo Doni and his wife Maddalena, a couple who had married in 1503 and whom Raphael must have painted in the period 1505-08. In his earlier portraits, which depended upon a Flemish formula of a three-quarter length figure seen behind a ledge with landscape in the background, the spectator is struck by individual details. In the Doni portraits the overriding impression is of the monumentality of the figures and their firm position in space. The arms form the basis for a solid pyramid that has as its apex the sitter's head; this and the new feeling that these are solid figures who inhabit a real space within the picture (together with the strong shadow that is cast by the light falling from the left on Agnolo Doni) reflect Raphael's reaction to Leonardo's *Mona Lisa*. He retains, however, much greater interest in the accidents of the sitters' appearance than does Leonardo and this is also true of the clothes that they wear where, as in the landscape background, Raphael adheres to the older outlook that has its roots in the achievement of Perugino.

PORTRAIT OF AGNOLO DONI

Pitti Palace, Florence

Oil on panel, 63 x 45 cm

PORTRAIT OF MADDALENA

DONI

Pitti Palace, Florence

Oil on panel, 63 x 45 cm

Private Devotional Paintings

Raphael's ability to assimilate Leonardo's innovations and to combine them with older traditions develops in a series of panels of the Holy Family which date from this period and which continued after his removal to Rome. These small devotional paintings were the stock-in-trade of Renaissance workshops and Raphael had already begun before moving to Florence with, among others, the *Madonna Conestabile*. The Virgin holds the Christ Child who turns across her to the apple which she originally held, now transformed into a book. All the elements, the turn of the Virgin's head and her features, and the Christ Child, a diminutive version of the Michelin Man, incapable of organic movement, were adapted from Perugino's stock-in-trade. Raphael's development was at first relatively slow and is made more difficult since dating is often uncertain and depends upon reading dates on the hem of the Virgin's robe. The *Virgin and Child with St. John the Baptist and an Unidentified Saint* (the *Terranuova Madonna*) is by common consent one of the earliest to show the influence of Florence. The Virgin's oval head, her robes and the landscape background link to the *Conestabile Madonna* but Leonardo's influence can be felt in the Virgin's heavily-lidded eyes and her lips which accentuate the head's plasticity.

Madonna Conestabile

Hermitage, St Petersburg

Tempera on panel, transferred to canvas, diameter 18 cm

The gentle, warm shadow, developed from Perugino, is more pronounced both around the Virgin's neck and on the Christ Child and, like the gesture of the Virgin's left hand, taken from the *Virgin of the Rocks*, reveals his debt to Leonardo.

Raphael retains an interest in local colour, that in Leonardo is suppressed by the depth of shadow, both in the *Terranuova Madonna* and in the *Virgin and Child with St. John the Baptist* (the *Madonna of the Meadow*) now in the Kunsthistorisches Museum, Vienna, one of the pictures dated on the hem of the Virgin's robe most probably to 1506. The format of the painting with the full-length Virgin seated in a landscape with the Christ Child and the infant St. John

reflects Leonardo's innovations in his *Virgin of the Rocks*, even though that was painted in Milan; the Virgin is now much more recognisably Leonardesque in expression and in her pose as she twists back to hold the Christ Child and so to form the main pyramid in the panel. This is completed by the youthful Baptist whose kneeling pose echoes the line of the Virgin's right leg, and whose cross forms a secondary pyramid with the Christ Child. It is probably difficult to share the eighteenth and nineteenth century Romantic enthusiasm for this part of Raphael's oeuvre but his influence on

VIRGIN AND CHILD WITH ST. JOHN THE BAPTIST AND AN UNIDENTIFIED SAINT (THE TERRANUOVA MADONNA)
Gemäldegalerei, Berlin
Oil on panel, diameter 86cm

VIRGIN AND CHILD WITH

ST. JOHN THE BAPTIST

(THE MADONNA OF

THE MEADOW)

Kunsthistorisches Museum, Vienna

Oil on panel, 113 x 88 cm

Nazarene painting, for instance, serves to remind us that he is successful in resolving formal problems. He links them with a clear understanding of the psychological roles of the characters: the concerned protective mother, the playful but timid Christ Child and the Baptist who kneels in adoration of the child who he knows to be greater than himself. The restrained mood is further enhanced by the almost lyrical landscape in which the figures are set, whose success is attested in the name by which the painting is commonly known, the *Madonna of the Meadow.*

Both the formal and the psychological possibilities of the Vienna panel were capable of almost limitless variations; the *Virgin and Child with St. John the Baptist* (*La Belle Jardinière*) in the Louvre is one such which dates from the following year, 1507 (the date is on the Virgin's mantle). The landscape, although belonging to the same type, is worked out with greater detail in the middle distance and there is a comparable change in the figures; the Virgin is more plastic and her robes are more complex (especially where the blue outer robe swirls over the red mantle at her back). The Christ Child's twisting pose is new, and derives from the Christ Child in Michelangelo's *Madonna*, in Notre Dame, Bruges. This is the first of many debts to Michelangelo to appear, and is very typical; the *contrapposto* of Christ's legs relate almost directly to the Michelangelo, but the pose of his arms, the twist of his head and the expression are all new, and carefully related to the present panel where the pyramid into which the figures fit is no longer so simple as in the Vienna panel. Raphael was not the only artist to understand the possibilities both of moving the apex of the main pyramid away from the central axis and of making the subsidiary figures nearly as important as the main one, for there is a comparable development in Leonardo's second cartoon of the *Virgin and Child with SS. Anne and John the Baptist*, National Gallery, London, from this period.

Raphael develops both ideas in the *Holy Family under the Palm Tree* in the National Gallery of Scotland, Edinburgh, on loan from the Duke of Sutherland.

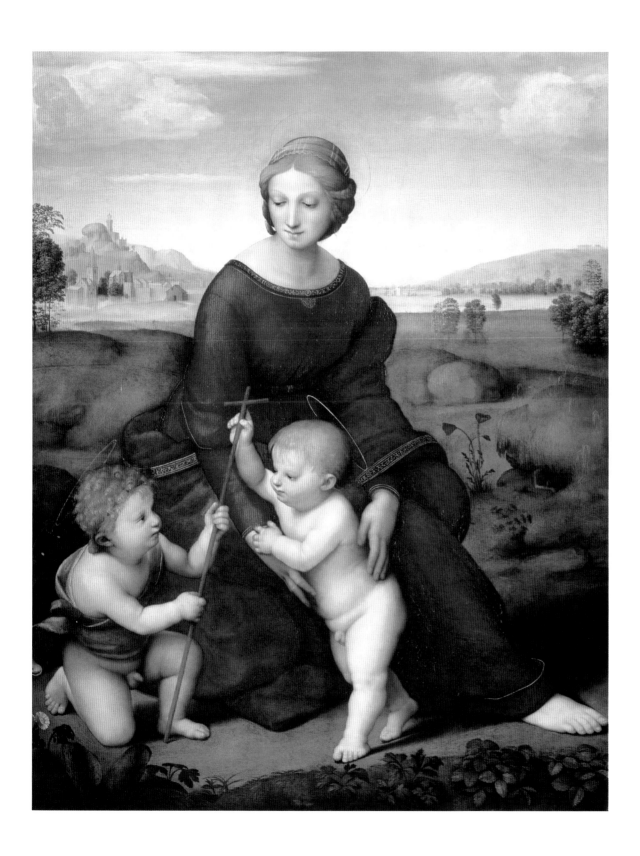

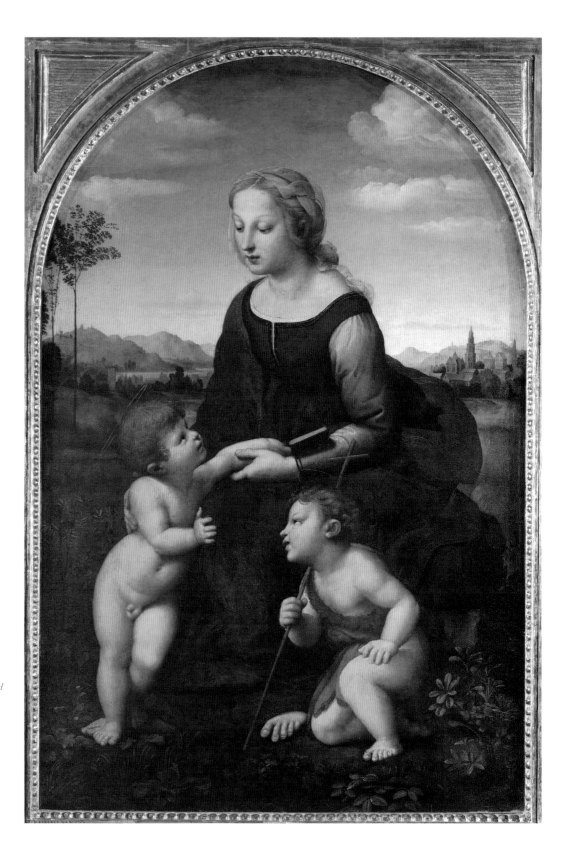

VIRGIN AND CHILD WITH ST.

JOHN THE BAPTIST

(LA BELLE JARDINIÈRE)

Louvre, Paris

Oil on panel, 122 x 80 cm

FAR RIGHT: HOLY FAMILY WITH

SS. ELIZABETH AND

JOHN THE BAPTIST

(CANIGIANI HOLY FAMILY)

Alte Pinakothek, Munich

Oil on wood, 131 x 107 cm

The picture, unlike the others which have no textual basis in the Bible, shows a moment of repose during the Holy Family's flight to Egypt; the Virgin rests on a ledge with a palisade behind her and the Christ Child leans forward and has to be restrained from falling off her lap as he plays with the bunch of flowers that the kneeling St. Joseph holds in his left hand. The Virgin's complex robes, which are similar to those in the *Belle Jardinière*, reflect the costume that Leonardo had created in his now lost cartoon of the *Virgin and Child with St. Anne*. Mary, who is seen in profile, sits to the right of the panel, her importance underlined by the palm-tree while St. Joseph forms another, slighter pyramid. The interplay between the two figures is further enlivened by Raphael's response to the tondo form, most notably in the curve of St. Joseph's back and the sweeping fall of the folds of his robe.

HOLY FAMILY UNDER THE PALM TREE
National Gallery of Scotland, Edinburgh, on loan from the Duke of Sutherland
Wood transferred to canvas, diameter 140 cm

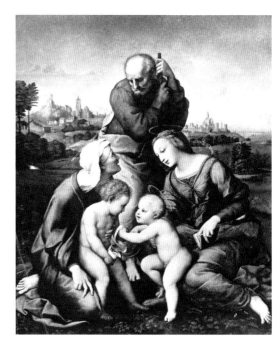

The composition of the *Holy Family under the Palm Tree* finds parallels in the group of the Virgin and St. Elizabeth squatting on the ground facing each other with their children playing in their laps in the *Holy Family with SS. Elizabeth and John the Baptist* (*Canigiani Holy Family*) in the Alte Pinakothek, Munich. The early stages of the design, which are known through a preparatory drawing and copies after other lost sketches, heightened this parallel by concentrating upon these two groups. Raphael must have found it difficult to achieve the necessary unity, for the final design is transformed by the inclusion of St. Joseph towering above both groups as he leans on his stick and looks down at St. Elizabeth. Although he stands behind the mothers with their children, the upper part of his body and his head are brought into the front plane so that he forms the apex of the triangle that binds the figures together, which would have been given added prominence by the glory of angels formerly at the top right and left of the panel which has now disappeared because of damage. The *Canigiani Holy Family* was a private devotional picture, illustrating no precise biblical text painted for a member of a distinguished Florentine family.

FAR RIGHT: MADONNA

DEL BALDACCHINO

Pitti Palace, Florence

Oil on panel, 277 x 224 cm

LATER PUBLIC COMMISSIONS

Madonna del Baldacchino and *Entombment*

The success of Raphael's private commissions lead to at least one public commission for Florence; in July 1506 Bernardo Dei left money for an altar in the family chapel in S. Spirito and the commission was given to Raphael who, presumably, referred to this picture in the letter to Simone Ciarla, from Florence on 21 April 1508. He noted that the cartoon was ready but he had not agreed a price because he would get a better price by having it valued once it was finished. Raphael was able to leave the altar unfinished on his departure for Rome, because he had no contract with the Dei. It also underlines how highly he must have regarded his prospects in Rome in abandoning his one public commission in Florence without payment. That the *Madonna del Baldacchino* was left unfinished is attested by Vasari, by the picture's cleaning and restoration in 1991 and by its provenance from Pescia Cathedral, where it had been transferred by the executor of Raphael's will after the artist's death in 1520. Sts. Peter, Bernard (the patron's name-sake), James and Augustine stand at the foot of the Virgin's throne which is set in front of a cloth of honour suspended from a baldacchin, most of which was a later addition. Raphael transforms the *Virgin and Child Enthroned with SS. John the Baptist and Nicholas of Bari* through the energy with which the saints converse and involve the spectator. These changes are reflected in the group of the Virgin and Child; her twisting pose is more complex and spatially worked out than in the earlier altars, and the child on her lap is larger and more energetic as he turns to look affectionately at St. Peter.

The cleaning showed that the execution had been far advanced before its abandonment, and that the colour scheme was close to being realised, with St. Peter's green vestment and yellow cloak balanced by St Augustine's red cloak. Perhaps the most significant discovery was that all the elements are by Raphael. This puts to rest the view that the background and the flying angels, close to those in the Chigi chapel

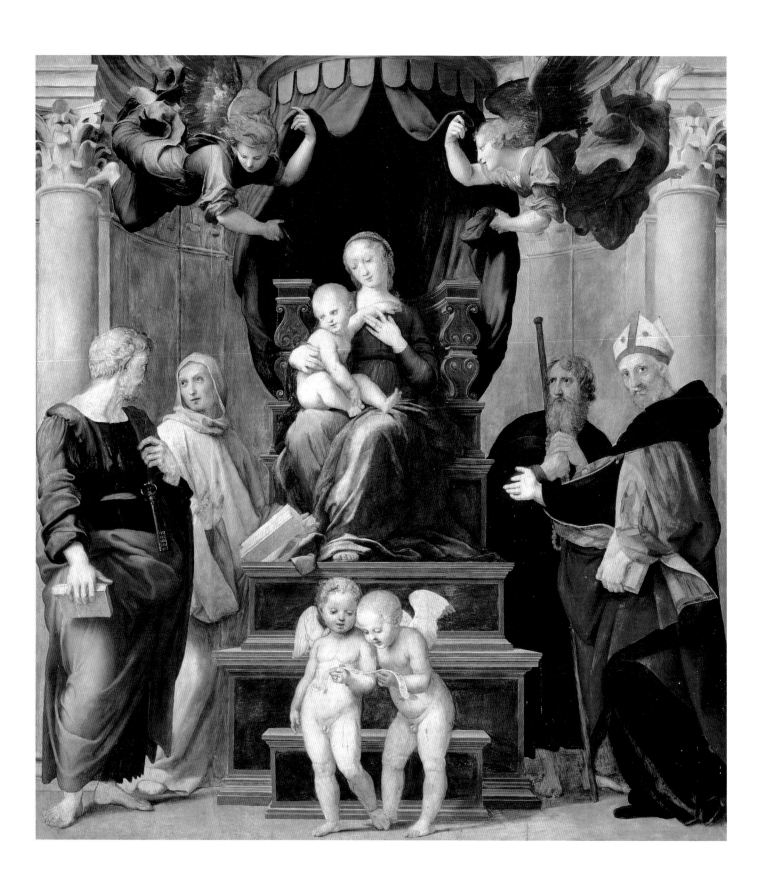

in S. Maria del Pace, were later additions. The great columns at either side of the altarpiece show that it was intended for the family chapel in Santo Spirito, for they resemble those of the church's nave, which are repeated at each side of the curved chapels. These may have prompted the curved niche, which was not shown in the first compositional sketch, but this also reflects developments in the Venetian *sacra conversazione*, relayed to Florence by Fra Bartolommeo. Shortly after his visit to Venice in spring 1508 he introduced deep niches into the background of his altars, in a manner which shows the influence of Giovanni Bellini's recently completed San Zaccaria altar in Venice. Otherwise the influence runs from Raphael to Fra Bartolommeo, who adopted both the St. Peter and the St. Augustine in his *Marriage of St. Catherine* in the Louvre of 1511. He was not alone in admiring the *Madonna del Baldacchino* since in the next decade the Christ Child influenced first Andrea del Sarto and then Rosso Fiorentino's hyper-active figures.

Raphael's decision to forego payment for the *Madonna del Baldacchino* is all the more surprising in the light of a note which refers to his other major public commission in this period, the *Entombment* in the Borghese Gallery, Rome, in which he tells his correspondent Domenico Alfani to ask Atalanta Baglione for payment. The *Entombment*, which is signed and dated 1507, was commissioned for the Baglione family chapel in S. Francesco, Perugia and such was its fame that a hundred years later it was stolen from its original location for the collection of the then ruling Pope, a member of the Borghese family. Such fame was well-merited, for the *Entombment* is the major public demonstration of the many lessons that Raphael had learned in Florence and of his ability to work successfully on a large scale that was to be so important in Rome.

The dead Christ, his right arm hanging limply down and his left arm supported by one of the Marys in the centre of the panel, is lifted by two bearers one of whom steps up towards the tomb that can be seen in a hollow of the rock on the left of the

panel. The two bearers hold Christ in a shroud and appear to be helped by an older man, presumably Joseph of Arimithea, while St. John clasps his hands in mourning. This foreground group, which is unified by the sweeping curve of Christ's body which is continued in the arms of both of his bearers, contains an impressive variety of movement and expression. St. John is grief-stricken as he looks down at Christ, Mary is concerned as she presses forward and St. Joseph leans back in a pose that suggests the effort involved; they walk to the left in a movement that is continued by the younger bearer who leans back to take the weight as his companion starts to climb the step. The angle of his shoulders as he pulls back, his head seen in profile and his red mantle, whose brilliance has been revealed by the recent cleaning, are intended to link both with the group carrying Christ and with that around the swooning Mary. The Virgin and her companions are set further back in the picture space than the main group with whom, however, they are linked by the figure of the attendant so that the overall grouping of the figures is that of a frieze greatly extended in depth. This is further enhanced by the landscape setting where the middle-ground is simplified and the horizon is carefully related to the attentive heads in the foreground leaving a striking view of Golgotha with its three deserted crosses above the Virgin.

When the *Entombment* was removed from the original site it was separated from the lunette of *God the Father Blessing*, now in the Gallery in Perugia. Although not painted by Raphael, it helps provides the context for the upward glance of the older bearer on the left. The composition with the frieze of figures set in depth within a landscape which anticipates Raphael's Roman work, the *Charge to Peter* (page 105) for instance, where the same compositional idea is realised with a more monumental figure-style, was not achieved easily. A striking series of drawings clarifies the development from a *Lamentation over the Dead Christ* to an *Entombment* with a freedom which recurs in later works, notably the *Transfiguration* (page 160), and which is itself a sign of the rise in the status of the artist.

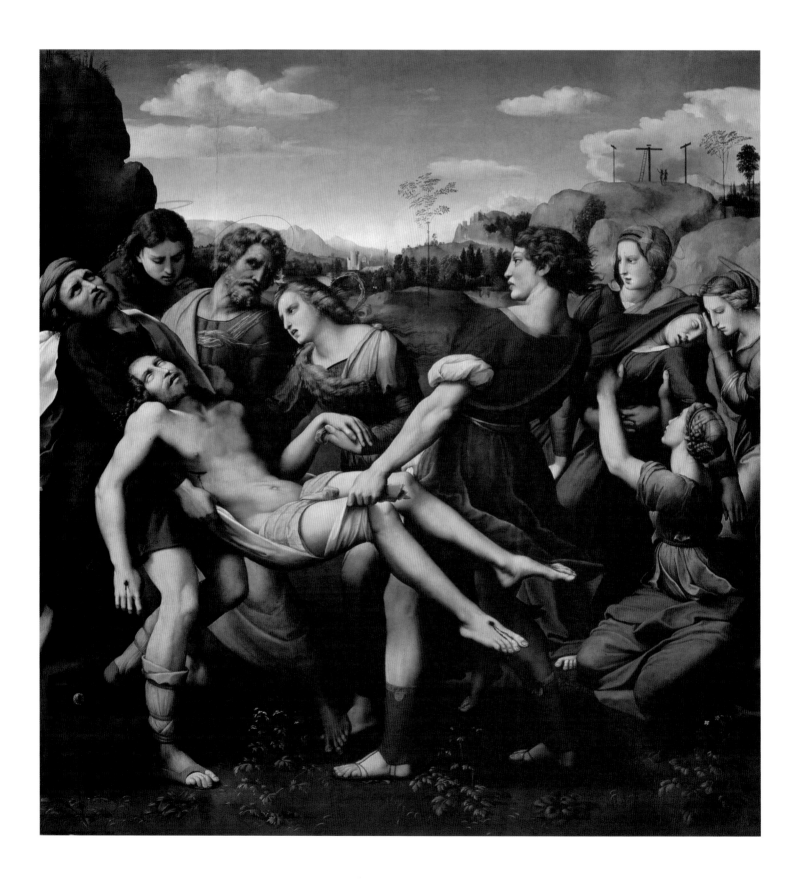

LATER PRIVATE DEVOTIONAL PICTURES

The sense of drama in the *Entombment* shows Raphael ready for large-scale commissions in Rome, but capable of transforming the private devotional panels. In the *Bridgewater Madonna* in the Duke of Sutherland's collection on loan to the National Gallery of Scotland, Edinburgh, the Virgin looks down at the Christ Child who almost dives off her lap in his energetic twisting pose. Here again Raphael reworks a Michelangeloesque motif, for Christ's movement has its origin in the sculpture, *Taddei Madonna*, now in the Royal Academy, London, where he recoils from the goldfinch which St. John offers him. A rapid sketch from memory of Michelangelo's marble tondo formed the starting point for the *Bridgewater Madonna* but Raphael was too aware of the dangers of plagiarism not to make considerable changes; Michelangelo turned the Christ Child to the spectator's right and left one leg down while Raphael reversed the movement and brought his legs together so that he is supported by the Virgin's lap while her hands echo the child's pose. These changes were worked out in a brilliant series of sketches which never lost sight of the tender interplay of glances between mother and child that together with the richness of the colour make the *Bridgewater Madonna* such a successful interpretation of a theme that Raphael treated so often.

These devotional paintings originally hung as votive icons to protect the family in private and public rooms. With Raphael (together with Leonardo and Michelangelo in Florence and Giovanni Bellini in Venice) they outstripped this pious function to become 'works of art' in the modern sense. There was a comparable, but much more limited, demand for images of individual saints -say because a modern John would like an image of his name-sake saint. The *St Catherine* in the National Gallery, datable 1507, witnesses a similar development in these images. The saint twists her whole body with a most elegant movement, emphasised by the lines of the folds of her grey robe – with green sleeves – and red cloak. Such movement, derived from Raphael's study of Leonardo's drawings, stands at the threshold of the 'serpentine' figure, so

FAR LEFT: ENTOMBMENT

Borghese Gallery, Rome

Oil on wood, 184 x 176 cm

beloved of Hogarth, but is subordinated to her piety, emphasised through the wheel on which she will be martyred and her intense upwards gaze to the heavenly light. With the *Bridgewater Madonna*, the *Madonna of the Pinks* and the *St. Catherine* Raphael had mastered the lessons of Florence and was ready for the challenge of Rome.

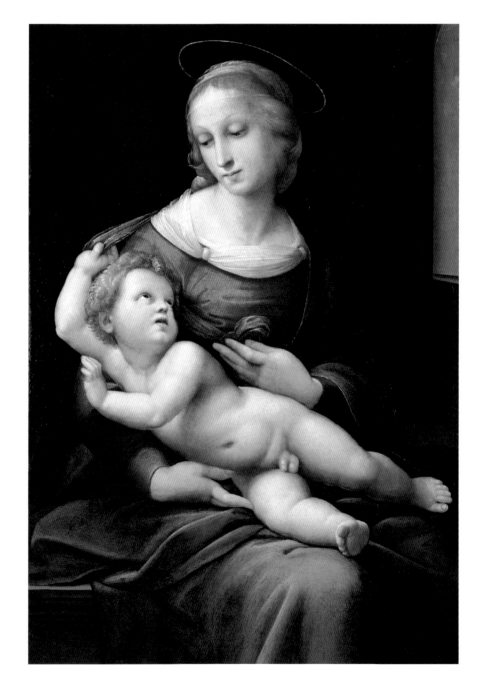

BRIDGEWATER MADONNA

National Gallery of Scotland,
Edinburgh, on loan from
the Duke of Sutherland

Oil on wood, transferred to canvas,

81 x 56 cm

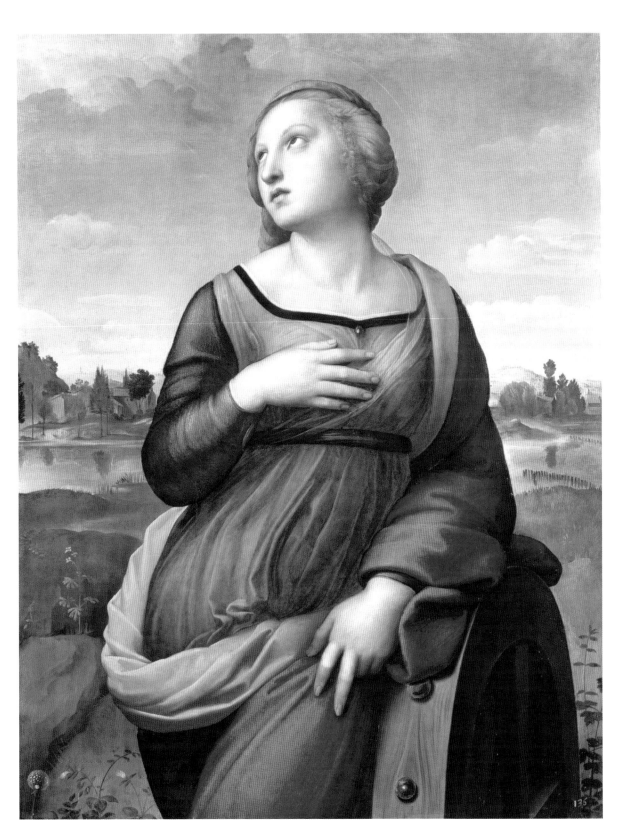

St Catherine
National Gallery,
London
Oil on wood, 71 x 56 cm

The *Stanza della Segnatura*

Introduction

The power of the Papacy rested on the spiritual supremacy of the Pope as ruler of the whole of the Catholic Church, which had to be constantly reasserted against the claims of those who wished to see the Church run instead by a council, and on its domination of Rome and the surrounding papal states, which had to be maintained by force of arms. Only with the Papacy re-established in Rome could the city flourish, for in addition to the trade created by the papal court and the cardinals, the city itself was the centre of a large pilgrimage trade which was important for its economy. Because of this the city's typical trades were luxury or service ones like jewellers, silversmiths and hotel-keepers, while the other major element comprised the bankers who controlled the distribution of benefices and raised the long and short-term loans so vital to running an extended bureaucracy like the Papacy. While the Pope was the hub of all social and economic activity in Rome, he was joined by the grandest cardinals with their large groups of followers who lived in palaces and villas intended both to impress with the magnificence of their lifestyle and to revive the glories of the Roman Empire.

This represented a new direction for the Papacy, as they moved from emulating the great Old Testament figures, above all Solomon, to rivalling the pagan Roman Empire in the person of Julius Caesar. This is explicit in Giuliano dell Rovere's choice of *titulus* on his election as pope in 1503 – Julius II. This both played upon his name (Giuliano-Julius) but also referred explicitly to Caesar. This was made clear in his triumphal procession of Palm Sunday when he processsed through the city like a triumphant emperor on his way to mass in the Sistine chapel. The comparison was hammered home on the commemorative medal: on the obverse was inscribed 'BENEDII.QU.VENIT.INO.D ('Blessed is he who comes in the name of the Lord', the greeting to Christ as he entered Jerusalem on Palm Sunday used in the canon of that day's mass) and on the reverse 'IULIUS. CAESAR. PONT II' which proclaimed Giuliano as the second Caesar.

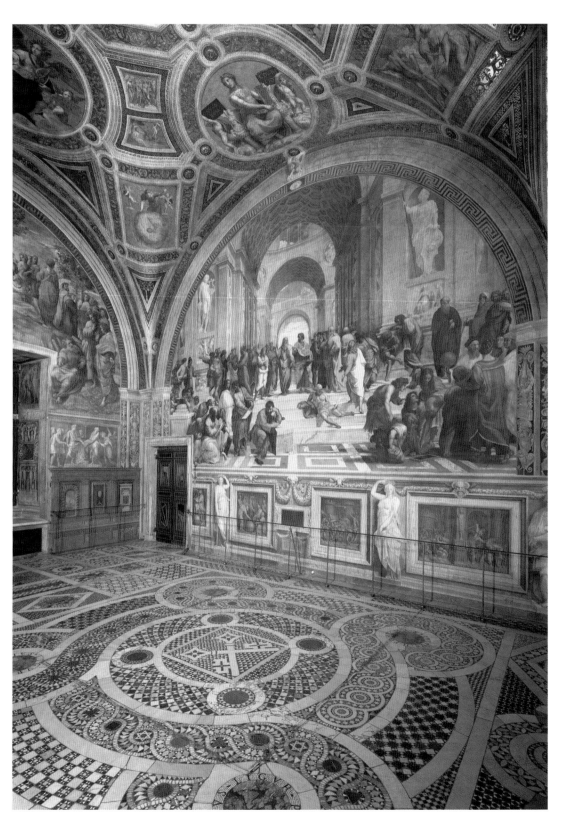

This was the culmination of a a revived interest in the glory of Rome which had begun with Petrarch in the fourteenth century and which, with the return of the Papacy from Avignon in the fifteenth century, lead humanist scholars to explore the ruins. They returned to classical sources to shake off the fanciful identifications which had developed in the Middle Ages, a process which culminated in Raphael's letter to Pope Leo X on his project to map the city's antiquities. These remains were more extensive than anything which Raphael could have seen before and they were matched by the great collections of classical statues, some of which were displayed in public but most of which were in private collections. The greatest of these was that of Pope Julius in the Belvedere which was still being added to. Other important ones were owned by the sculptor Andrea Bregno, Giovanni Ciampolini as well as Cardinal Cesi, Cardinal Carpi. Cardinal Grimani and Cardinal Andrea della Valle. Raphael may have had the opportunity to study classical reliefs before he came to Rome, but these collections provided a range of large-scale stone statuary that could not be matched anywhere else in Italy, or the world, and had an immediate impact upon him.

THE CEILING

Pope Julius II was one of the Church's great architectural patrons. He began to rebuild St. Peter's under the direction of Bramante, where his predecessors had sought a new choir. Bramante was also responsible for the scheme to transform the hill which leads from the Vatican palace to the Belvedere villa in a great series of steps which transformed all subsequent villa designs. Julius II disliked the suite of rooms in the Vatican palace which had been decorated for his predecessor Alexander VI by Pintorricchio with a series of frescoes full of personal allusions. Late in 1507 Julius II moved in the Torre Borgia to a new suite of rooms, a floor higher. This consisted of a public audience chamber, the *Sala di Costantino*, followed by three smaller rooms, with the *Stanza della Segnatura* at their centre. At first the decoration was entrusted to a group of artists, which included Sodoma, Bramantino and Lorenzo Lotto, while later it became the responsibility of one man, Raphael. The date of his introduction and the

reasons for his presence in Rome remain unclear, but he was probably brought there in 1508 through Bramante's initiative. As Papal architect he had designed the frame of the ceiling, whose central octagon and some of the smaller panels had been painted by Sodoma before Raphael began work with the four tondi and their accompanying rectangular panels.

THE CEILING OF THE STANZA DELLA SEGNATURA, VATICAN PALACE

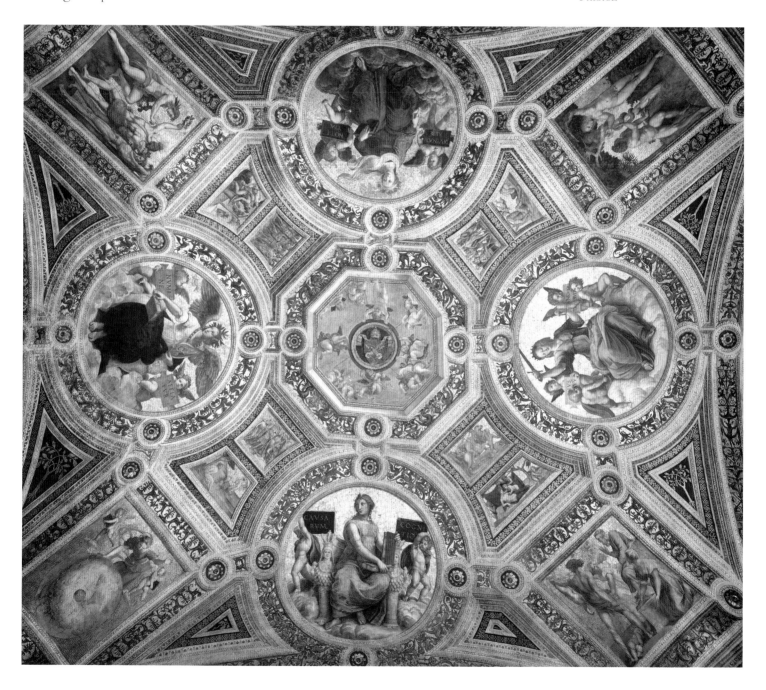

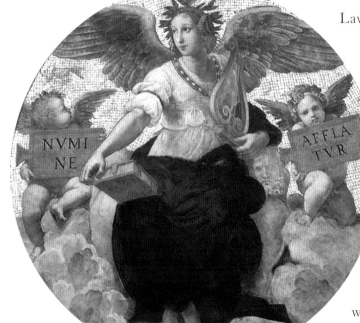

POETRY

PHILOSOPHY

The choice of the faculties of Poetry, Philosophy, Theology and Law presents a problem since it is without precedent and does not fit with any of the systems of the cardinal or theological virtues. Explanation of the programme in terms of the rooms' functions is equally unsatisfactory. One of the Curia's supreme tribunals, the *Segnatura Gratiae*, after which Vasari named the room, met in the adjoining *Stanza dell' Incendio*. Discarding, as we must, Vasari's view that the room was used by the *Segnatura* we are left with the hypothesis that it served as Julius' private library. This is also open to criticism. The space under the frescoes available for wall cabinets, when due allowance is made for the doorways and windows, would have left Julius' small but select collection of manuscripts more cramped than in most Renaissance libraries. The division of the ceiling into Theology, Philosophy, Poetry and Law does not match either with Julius' collection – it makes no allowance for history – or with the traditional divisions used in contemporary catalogues of book and manuscript collections.

That the decoration of the *Segnatura* was always intended for a public audience is underlined by the overtly propagandistic programmes of the later rooms, and by the example of other Renaissance palaces, where studioli were accessible to visitors. Although there is no convincing account of the *Segnatura's* original function, its combination of the sacred and the profane matches – in different terms – the renewed classicism of Julius' court. The papal secretary, Paolo Cortesi, dedicated to Julius II a body of writings, whose expression

of Christian ideals in a rhetorical language steeped in the study of
Cicero affords a parallel with the renewed classicism of the
Stanza della Segnatura. The parallels work at a number of
levels and reflect Julius' personal involvement in the
scheme. By contrast with the blatant praise of
Alexander VI in Pintorricchio,s decoration on the
floor below, this was restricted to the constellations
contemplated by Urania, which record the
disposition of the sky over Rome at the moment of
Julius' election as Pope, three hours after sunset on 31
October 1503. The wall frescoes are framed by an
illusionistic moulding, which, together with the
keystones, resembles triumphal arches. They contrast with
the slighter forms of Raphael's immediate precedents, the frames
used by Perugino in the *Cambio* in Perugia and by Signorelli at
Orvieto. The reference parallels the use of an updated Arch of
Constantine in Julius' procession from S. Maria del Popolo to
the Sistine chapel on Palm Sunday 1507. Finally Apollo's
appearance in the *Parnassus*, with Mount Helicon set
above the Mons Vaticanus, alludes to the presence of
the Apollo Belvedere in Bramante's project for the
Belvedere. The link was further emphasised by the
subsequent ceremony in which Julius was crowned as
a poet on Apollo's sacred hill, the Mons Vaticanus.

Throughout the *Stanza della Segnatura* the challenge of
working for the second Caesar prompted a new level of
archaeological reference to Roman collections of classical
sculpture, both public and private. In the earliest work, the
ceiling frescoes, this was combined with the legacy of Raphael's

THEOLOGY

JUSTICE

intense scrutiny of Leonardo and Michelangelo. The Florentine influence can be seen both in the rectangular narrative scenes and in the four tondi. Poetry, Philosophy, Justice and Theology are seated on clouds in front of an illusionistic gold mosaic background and accompanied by *tituli* drawn from Vergil, Cicero and the *Corpus Iuris Civilis* of Justinian. Both Poetry and Theology were painted in the mode of Raphael's Florentine work, while the mosaic background resembles that which Perugino had used in his frescoes in the Cambio in Perugia. The lyre held by Poetry was one of the first fruits of the new concern with archaeology, which was developed in the twin statues of Diana of Ephesus on Philosophy's throne. The monumental and severe drapery of Philosophy and Justice has greater bulk than that of the other two figures and reveals the influence of classical statues.

WALL FRESCOES

Nothing in the ceiling prepares us for Raphael's mastery of scale and decorum in the four great wall-frescoes. The static individuals on the walls of Perugino's Cambio frescoes, representatives of the virtues on the ceiling, are composed into groups who react and discuss amongst themselves. The name *Disputà* should not mislead us to believe that there is any disagreement, but rather contemplation of the Trinity, emphasised through the golden rays behind God the Father and Christ. Christ is flanked by the Virgin and St. John the Baptist, with below: St. Peter, Adam, St. John the Evangelist, David, St. Stephen, and Joshua, St. Lawrence, Moses, St. James the Less, Abraham and St. Paul. The four evangelists are symbolised by extracts from the gospels which are held up by the four angels which flank the Dove of the Holy Ghost.

Not all the figures in the lower section can be identified but the four Latin doctors of the church who sit near the altar are clearly identified by *tituli* stamped into their haloes, with St. Gregory and St. Jerome on the left, SS. Ambrose and Augustine, dictating to a kneeling scribe on the right. St. Thomas of Aquinas and St.

Bonaventura are similarly identified in the group behind St. Augustine,s scribe. The mitred Pope between them is Sixtus II, while Sixtus IV stands on the next step down from the scribe in a rich cope with upraised right hand. Behind him Dante, crowned with laurel, links this side of the *Disputà* with the *Parnassus*. He is joined by figures from classical antiquity whose thought was believed to have heralded Christianity. Vasari recognised the head of the old man turning away from his book as Bramante (it recurs in the Euclid in the *School of Athens* opposite) and the monk on the very left may be a posthumous tribute to Fra Angelico.

The early drawings show that Raphael,s starting point for the lower part was Leonardo,s unfinished *Adoration of the Magi* in the Uffizi, Florence, whose influence extends from details both here (the pointing young man on the left) and in the *School of Athens* (the head of a man peering in around Pythagoras) to the general scheme with its movement in depth and the skill with which left and right are balanced, without too obvious symmetry. In the *School of Athens* the device of framing Plato,s and Aristotle,s heads against the open sky, seen through a distant arch, harks back to Leonardo,s *Last Supper* in S. Maria delle Grazie, Milan. The loose balance of left and right, shown in the Cartoon (page 40) was modified by the late introduction of the meditative figure leaning on a block of stone, where Heraclitus takes on the features of the brooding Michelangelo. Similarly the bearded Plato shows us Leonardo, as represented in his self-portrait in the Royal collection, Windsor.

The *School of Athens* illustrates the seven liberal arts. Rhetoric, a key element in the trivium, is embodied in Socrates, based on a well-known classical bust, counting off his debating points on his fingers. Dialectic is characterised through the dialogue between Aristotle and Plato (identified by the texts they hold the *Timaeus* and *Ethics*), while Grammar is embodied in the groups of young students busily writing or having their tablets corrected. The mathematical *quadrivium* – arithmetic, music, geometry and astrology – is represented through Pythagoras writing on mathematics, while a young boy holds a tablet with an harmonic scheme; on the

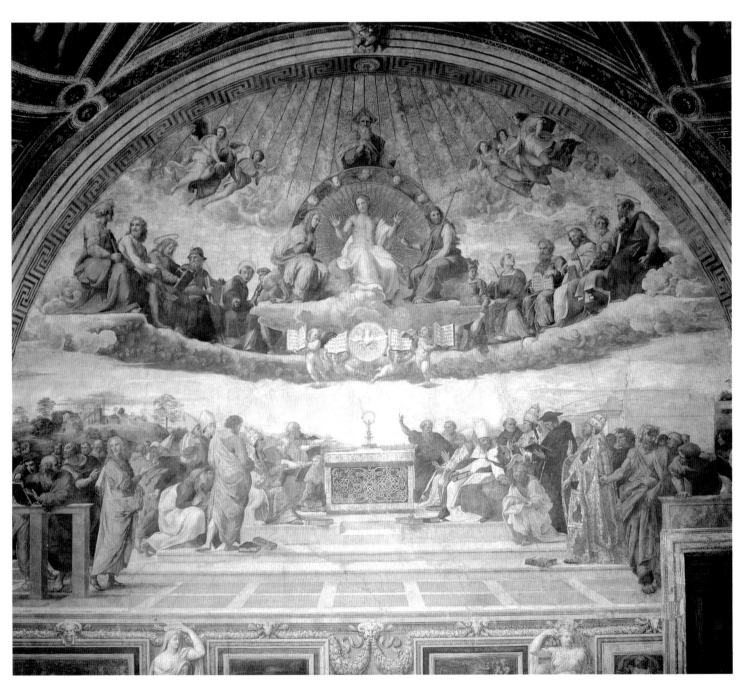

DISPUTÀ

Fresco, Stanza della Segnatura

other side Euclid (in the person of Bramante) bends down with his dividers to teach a group of young boys geometry. The two figures to his side holding globes, one terrestrial the other celestial, are the astronomers Zoroaster and Ptolemy besides whom we see the youthful Raphael.

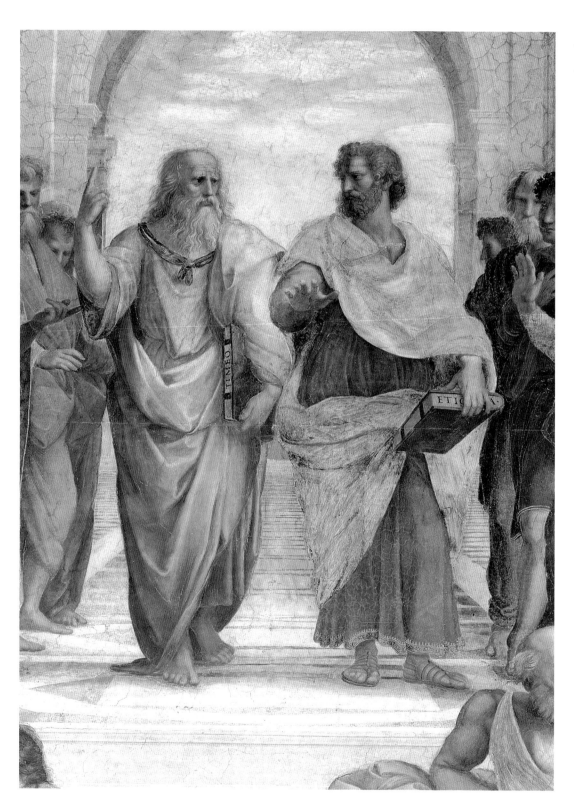

PLATO AND ARISTOTLE

DETAIL OF THE SCHOOL

OF ATHENS

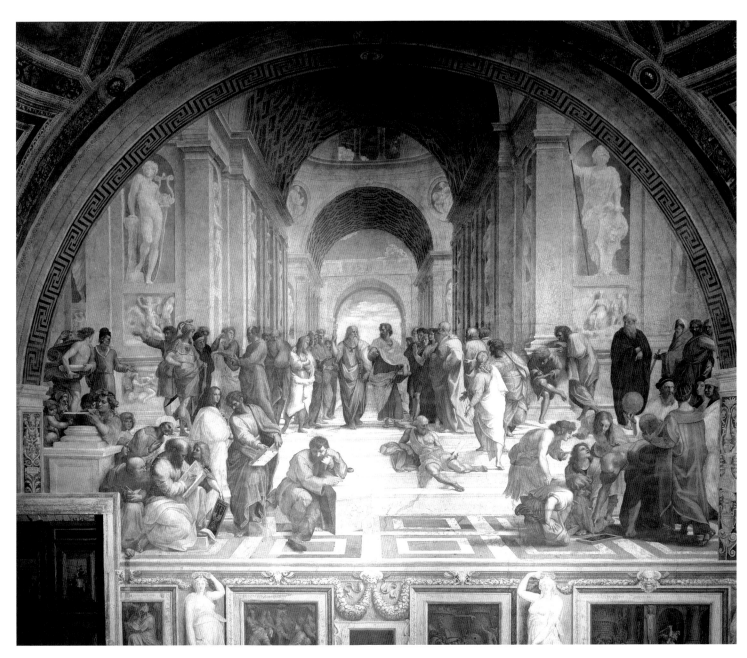

SCHOOL OF ATHENS

Fresco, Stanza della Segnatura

Raphael recreated the Athenian academy in gesture, costume and in the great building, whose front is dominated by mock classical statues. The giant piers of the Athenian academy and the patterning of its vaulted ceiling resemble Bramante's crossing of St Peter's, seen in Marten van Heemskerck's drawings. Raphael adapted Bramante's design in emulation of Hadrian's villa at Tivoli, which he had explored. His response to the grandeur of Bramante's St Peter's prepared for his success as the

architect of the Chigi chapel in S.Maria del Popolo, for his later quotation of the Tempietto in the *St Paul Preaching at Athens* and for the *Parnassus* on the north wall. This frames a view of the Mons Vaticanus, enclosed by Bramante's Belvedere, with Apollo on mount Helicon, his head raised to acknowledge his divine gift, surrounded by the muses together with poets of antiquity together with Dante, Petrarch and Boccaccio.

Raphael drew upon an incomparable range of classical sculpture for the frieze-like composition and the musical instruments, with the exception of Apollo's *lira da braccio*, a modern instrument, then identified as ancient. It has been carefully modified by the addition of two extra strings to bring the total to nine, the number of the muses whose harmony it symbolized. Poses and drapery were adapted from large-scale statues: the seated Apollo from the statue of the god in the Grimani collection, the complex clinging drapery of the muse seated to the spectator's left of Apollo from the Ariadne then identified as Cleopatra and still in the Maffei collection), the heads of the muses from those of Venus and the sightless but eloquent Homer from the recently discovered *Laocoon*.

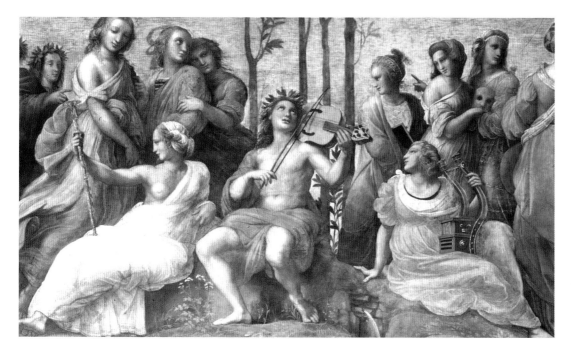

APOLLO AND A SEATED MUSE,
DETAIL OF THE PARNASSUS IN
THE STANZA DELLA SEGNATURA

PARNASSUS

Fresco, Stanza della Segnatura

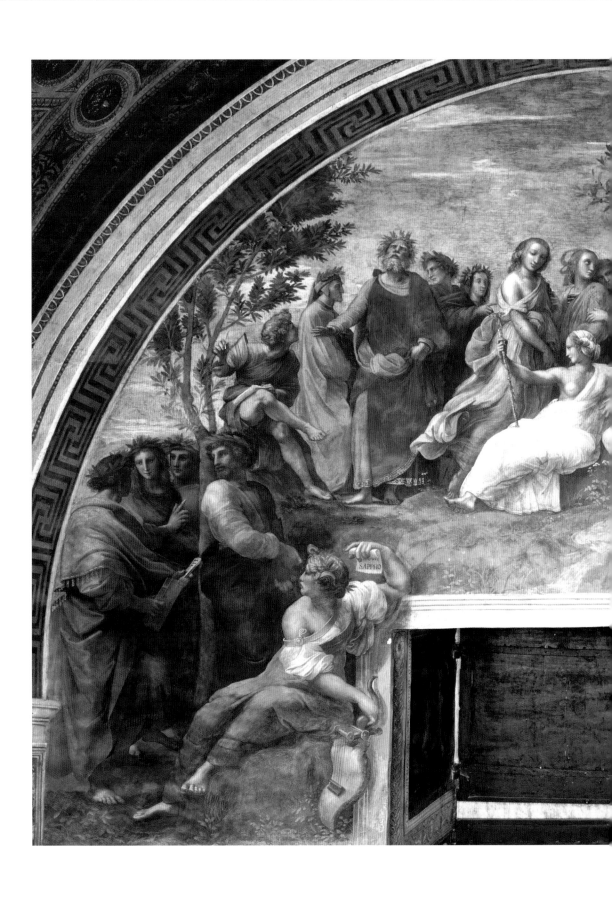

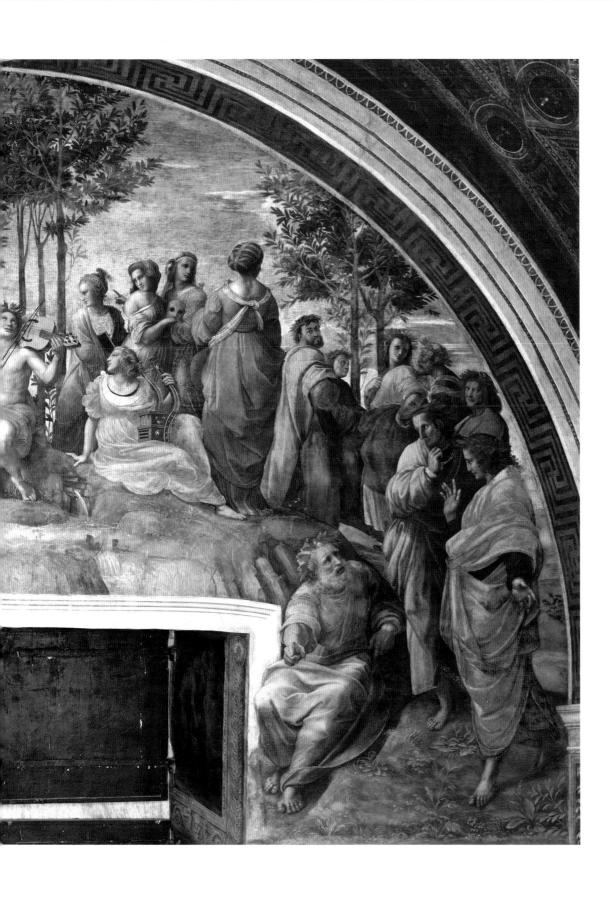

JUSTICE WALL

Fresco, Stanza della Segnatura

The nearly-unbroken linking together of Apollo, the muses and poets is an inspired reworking of the relief composition of Roman sarcophagi, not found in the early stages of the design, known through copies after lost drawings and an engraving by Marcantonio Raimondi, from a drawing by Raphael. This classical inspiration was combined with concern to reduce the intrusive window, by making it impossible for the spectator to work out the relationship of the side of the windows to the main field above. He covered the edge of the window on the left, for instance, with part of the mountain and Sappho's arms and lyre. She in turn is one of the group of poets standing behind the frame and the window. This deliberate ambiguity, which Raphael had first used successfully in the *Marriage of the Virgin*, (page 25) extends to the relationship of the foreground groups with the muses on Mount Helicon; the poet on the very right of the fresco appears to be closer to the spectator than Apollo but both have the same relationship to the frame and hence a comparable position in space which reduces the depth of the composition.

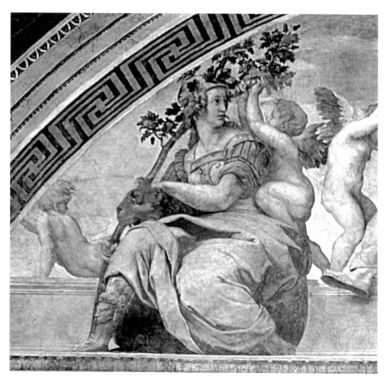

FORTITUDE, AND TEMPERANCE,

JUSTICE WALL

Stanza della Segnatura

The asymmetrical window of the south wall made it a difficult site to decorate and the heavy painted cornice above the window reflects the disparate character of the scheme with virtues above and histories below. Contemporary sermons laid fresh emphasis upon the Cardinal Virtues and here Fortitude, Prudence and Temperance are placed in the upper zone, which is divided from the narrative scenes by the heavy cornice, and so strengthens their connection with the fourth virtue (Justice) on the ceiling. Fortitude caresses a fierce lion while bending an oak tree, which formed part of the emblem of the Pope, whose family name, 'Rovere', means oak. Prudence reveals her character by scrutinising one face in the mirror while another bearded face at the back recalls the importance of memory and Temperance holds up the reins which restrain her actions. There is no canonical order for these virtues and the decision to place Prudence in the centre may reflect Julius II's view of his Papacy although few of his contemporaries saw him as a model of prudence. They were deemed to constitute 'public and civic virtue' in formulations taken directly from classical sources, notably Cicero. The novelty of the style, which has lead scholars to see here the intervention of other hands – Lorenzo Lotto has been suggested, and the scale can be brought out by comparing the heavily sculptural Prudence with Sappho in the *Parnassus*. Fortitude is a reworking of Justice on

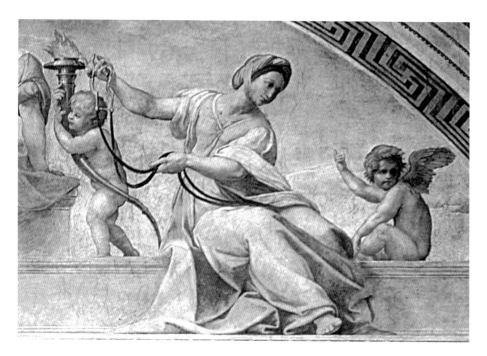

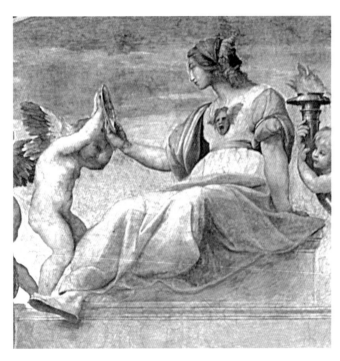

the ceiling with an energy and breadth of movement that reveals the impact of the Sistine Ceiling, which, according to Vasari, Raphael had seen before its official unveiling.

The two histories *Pope Gregory IX handing over the Decretals* and *Justinian handing over the Pandects* are aspects of the motto 'To each his due'. Gregory bears the features of

Pope Julius II and is surrounded by members of his entourage in a scene reworked from Melozzo da Forlì's fresco of *Sixtus IV together with his librarian, Platina*. Its companion emulates classical reliefs, like that of a barbarian submitting to Marcus Aurelius, re-used on the arch of Constantine. The profile-view of the emperor, the stool on which he is seated, his costume and the architectural niche (based on the remains of the Temple of Venus and Rome) demonstrate the care with which Raphael selected the sources on which he drew in his reconstruction of Rome's – to quote from his letter to Leo X – 'good antique period, which lasted from the early emperors up to the time when Rome was broken and ruined by Goths and other barbarians'. The supremacy of Papal law was suggested through Gregory's raised throne and bigger fresco field.

The *Stanza d'Eliodoro*

The programme for the *Stanza d'Eliodoro* is very different from that of the *Segnatura*, with a series of history paintings on the walls which have a contemporary political allusion which is echoed in the Old Testament scenes on the ceiling above. The ceiling had already been painted in the earlier campaign by Peruzzi and Ripanda and at first Raphael preserved their work, which in time he changed to fit with the bolder style of the wall frescoes. This is already clear in the relationship of the frescoes to the walls; the bottom edge runs parallel with the top of the doors and is supported by mock stone caryatids set in front of an illusionistic marble dado inset with small scenes by Raphael's workshop. The piers supporting the framing arches cut the bottom of the frescoes rather clumsily, but the system minimises the awkward placing of the doors (but not of the window on the southern wall, and enables the spectator to concentrate upon the growth in the scale and movement of the figures and architecture.

This is clear in the massive rustication of the outside of the prison from which St. Peter is freed on the north wall which is matched by the reduction in the number of the figures and the ease with which they dominate the space. St. Peter is shown asleep behind the bars of his prison, flanked on either side by guards, while the angel comes in a burst of light to free him and lead him out past more sleeping guards on the right. On the other side there is a variety of light sources with the moon coming out from behind a wisp of cloud and a torch held by a guard who rouses his companion while behind them another shields his eyes from the supernatural light. The great burst of light in the centre is the focus of attention and this use of a night scene, which is suggested by the text of Acts 12, 5 ff, also suggests the influence of Piero della Francesca who had worked on now destroyed frescoes in the Vatican and had created a brilliant night scene in his cycle of frescoes at Arezzo in the 1450s.

The *Mass at Bolsena* on the southern wall opposite records a miracle of 1263, in which year a German priest, who had doubts about the doctrine of transubstantiation,

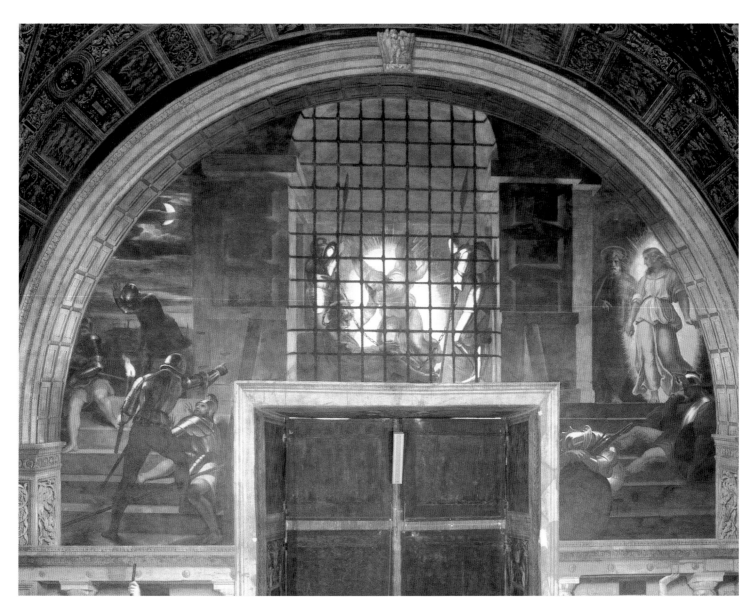

celebrated mass at Bolsena; at the moment of the consecration of the host it dripped enough blood to stain the corporal held by the priest and so assuage his doubts. The scene is given contemporary relevance by the presence of Pope Julius II kneeling in prayer to the right, isolated, like the priest, by the dark wooden curve of the dado against which the host stands out in the priest's fingers. Raphael continued the top of the window by the step on which the Pope kneels which creates a symmetrical space whose central axis is to the right of the window. When the Swiss Guard who accompany the Pope and the women on the opposite side are related to this wall they

FREEING OF ST PETER

Stanza d'Eliodoro, Vatican Palace

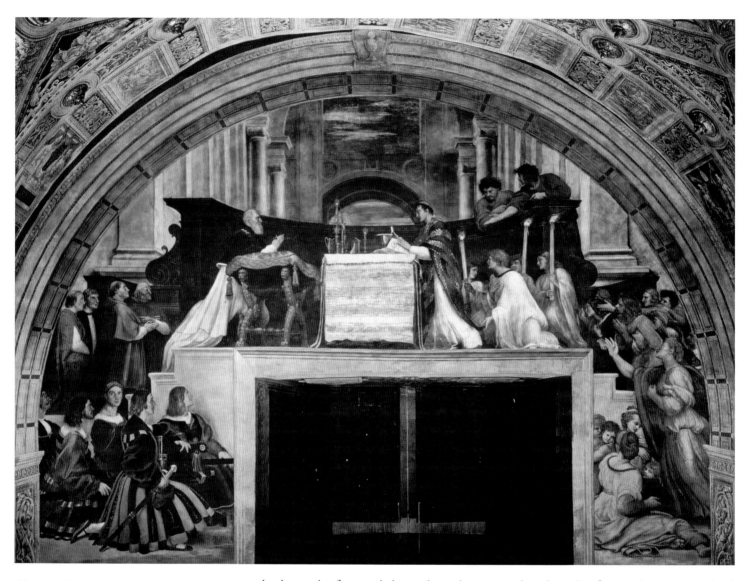

appear to be brought forward, but when they are related to the frame they are pushed back with a deliberate ambiguity that Raphael had already exploited in the *Parnassus*.

The Pope is present once more in the *Expulsion of Heliodorus* on the eastern long wall, borne aloft on the sedia gestatoria from which he witnesses the drama of the high priest's prayer which is answered by the horseman on the right of the fresco, who prevents Heliodorus together with his attendants from robbing the temple of Jerusalem. The drama is based on one of the apocryphal books of the Old Testament, that of Maccabees, which was popular in the Renaissance, partially because the titular

church of Julius II, S. Pietro in Vincoli, was believed to contain relics of the Maccabeen brothers. The high priest kneels in prayer in the centre of the fresco watched by some of the crowd, the rest of whom look across at the great white horse which has knocked down Heliodorus, who lies on the ground in a striking pose based upon that of the sculpture *Laocoon*; the horse poised above him is freely inspired by that which Leonardo had created in the centre of his cartoon of the *Battle of Anghiari* in Florence. The changes in the rider's costume and that of Heliodorus, which is based upon a study of Roman armour, reveal a concern for archaeology that is also shown in the seven-armed candlestick in front of which the priest kneels. This is based on that shown as part of the spoils brought back from the Temple of Jerusalem by the Emperor Titus on the inside of his triumphal arch. The energy with which the drama is enacted is matched by the new monumentality of the architecture, where the massive columns support the drum on which the dome rests.

The archaeological concern informs both the composition and the details of the last of the frescoes, the *Repulse of Attila* opposite which is based upon a meeting between Pope Leo the Great and Attila the Hun which the *Liber Pontificalis* (the official history of the Papacy) records as having taken place on the banks of the Mincio outside Mantua in 452. The Colosseum and the aqueduct in the background show that the encounter has been transferred to Rome. Many of the details of Attila's horde, the combination of curved and straight trumpets, the horse covered in spots and the strange fish-scale armour of its rider are derived from the Gauls on Trajan's column, whose long winding relief formed the inspiration for the composition, even though it is rendered in greater depth. Attila rides a black horse behind two footsoldiers who point up at the Pope, his hands are outstretched in surprise as he looks up at the heavens where the great dark clouds roll back throws into sharper relief SS. Peter and Paul who accompany Pope Leo the Great, in the person of Pope Leo X, who rides a white horse as he had done in his triumphal procession to the Lateran in April 1513. Copies of lost preliminary drawings show that originally Pope Julius II was carried on the sedia gestatoria to face the danger as in the *Expulsion*.

Expulsion of Heliodorus

Stanza d'Eliodoro, Vatican Palace

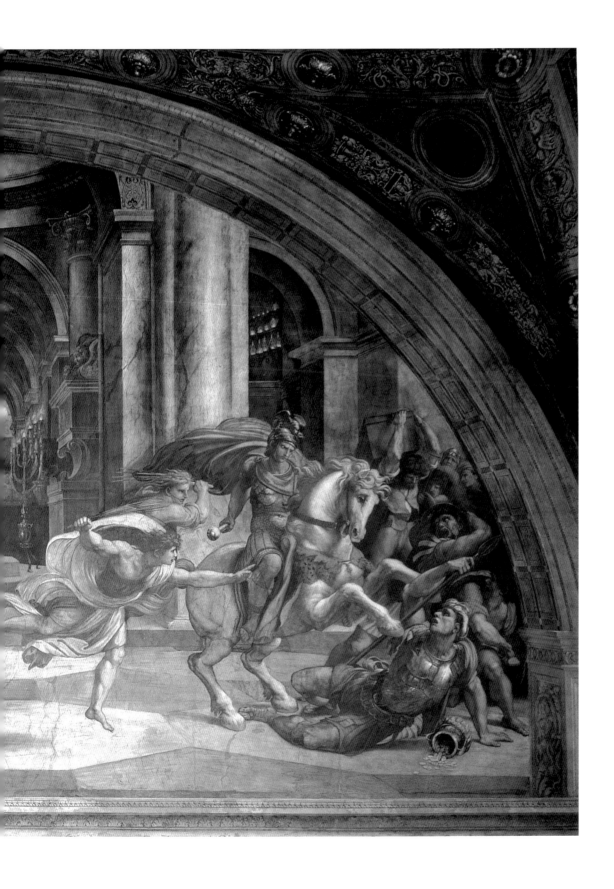

Raphael retained some of the original ceiling with its small scale paintings 'al'antica' but found that in the centre it contrasted with the histories; he cut away four of the stucco ribs (their bases can still be seen) to make bolder spaces which appear to be hung with illusionistic tapestries fixed to the remaining ribs. The Old Testament scenes which Raphael added after the walls complement the histories below; both *Jacob's Dream* and the *Freeing of St. Peter* depict visions which occurred at night. The *Sacrifice of Isaac*, which is above the *Mass at Bolsena*, prefigures the Mass in the lamb that the angel carries down Moses and the Burning Bush over the *Expulsion*, expresses the sanctity of God's holy places in the command to Moses: 'Draw not nigh hither' and Noah's thanks offering above the *Repulse*, illustrates God's command to Noah: 'And I will remember my covenant which is between you and me' as Noah realises that he has been saved.

REPULSE OF ATTILA

Stanza d'Eliodoro, Vatican Palace

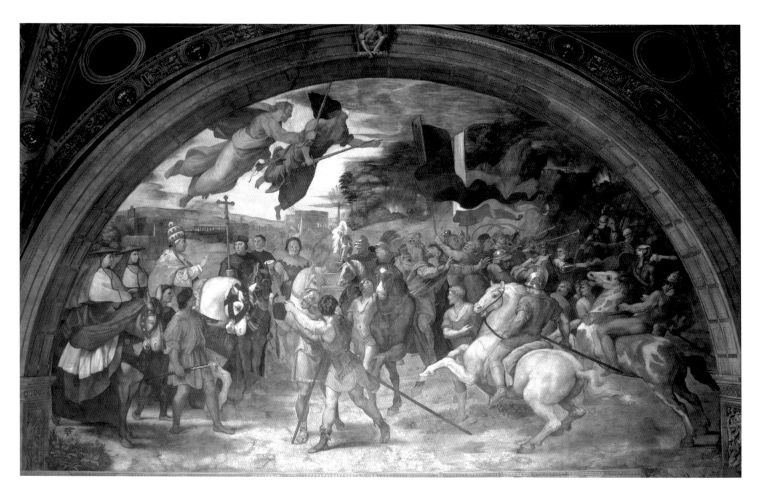

The dramatic programme of the room so well matched by the scale and power of Raphael's frescoes, was inspired by the turbulent events of Pope Julius's pontificate; the *Repulse* almost certainly reflects the expulsion of the French from Papal territory in 1512 while the *Expulsion of Heliodorus* may (although this is less certain) allude to Julius's triumph over the schismatic cardinals. They had formed a council under the protection of the French King in 1511, first in Pisa, and then later in Milan where they had decreed, for instance, that the Pope should be suspended from all spiritual and temporal administration in an attack which had clear parallels with that of Heliodorus upon the Temple of Jerusalem. The restoration of the church from its bonds is the theme of the Freeing which, like the *Mass at Bolsena*, had an added personal significance for Pope Julius whose titular church when a cardinal had been S. Pietro in Vincoli (St. Peter in Chains). He had made a special pilgrimage to the church in 1512 to offer his thanksgiving for the defeat of the French just as in 1506 he had paid a special visit to adore the miraculous relic of the Mass in its setting in the Cathedral Duomo of Orvieto.

The *Stanza dell'Incendio*

Contemporary events also provided the inspiration for the choice of subject in the next room, the *Stanza dell' Incendio*, which was presumably the new room to which Raphael referred in his letter to his uncle in July 1514. An inscription with the date of 1517 records the completion of the work but the designs had been prepared much earlier for by 1515 Raphael had sent to Dürer in Nuremberg a drawing, now in the Albertina, Vienna, of two nude men one of whom was used in the *Battle of Ostia* (page 31). Just before he began work on the *Stanza* Raphael was appointed architect to St. Peter's in succession to Bramante. The increasing demands made upon his time reduced the role that he was able to play in the execution of the frescoes but even so by 1517 he had presented the cartoon of one of the frescoes that he himself had painted to the Ferrarese agent in Rome to send to Alfonso d'Este, Duke of Ferrara.

It has been suggested that, unlike northern artists, those in Italy were not concerned with personal style and that the drawing that Raphael sent to Dürer was not by him but by one of his assistants; later in his negotiations with the court of Ferrara, for whom he was supposed to have painted an *Indian Triumph of Bacchus* which after his failure was replaced by Titian's *Bacchus and Ariadne* now in the National Gallery, London, he makes it clear that the cartoon of a portrait was by one of his garzoni. This together with the quality of the drawing sent to Dürer, superior in its realisation of forcefulness and light to anything by his workshop, suggest that Raphael played a large part in planning the frescoes of the room, although many details were elaborated by the workshop and, that he painted at least one of the frescoes himself, presumably the *Fire in the Borgo* from which the room takes its name.

The decorative system continues that of the previous room retaining Perugino's ceiling, which was taken into account in some of the wall frescoes, replacing the caryatids of the basamento by herms who flank a series of seated princes. At three of its corners the ceiling, appears to be supported by an Egyptian telamon used as an atlantes; these figures were based upon Egyptian statues which had been known to the Quattrocento and which in the sixteenth century flanked the entrance to the bishop's palace at Tivoli (now they are in the Egyptian collections in the Vatican). In April 1516 the Pope's private secretary, Pietro Bembo, referred to a trip that he was to make to Tivoli together with a group of friends including Castiglione and Raphael; the inclusion of the Egyptian figures is one outcome of the visit which had important repercussions for the design of the Villa Madama. This was Raphael's major architectural undertaking whose grandiose plans he did not live to complete. The Egyptian figures that Raphael used were highly prized in the Renaissance and were later admired by Michelangelo, they formed a part of the legacy of Imperial Rome's enthusiasm for Egyptian works of art, many of which had continued to be displayed throughout the Middle Ages; Raphael's interest in the two figures at Tivoli fits with the revived interest in Egyptian works of art that has its roots in late twelfth-century Roman sculpture and which had been given a new stimulus by the rediscovery of classical texts discussing Egypt.

FAR RIGHT: FIRE IN THE BORGO
Stanza dell' Incendio,
Vatican Palace

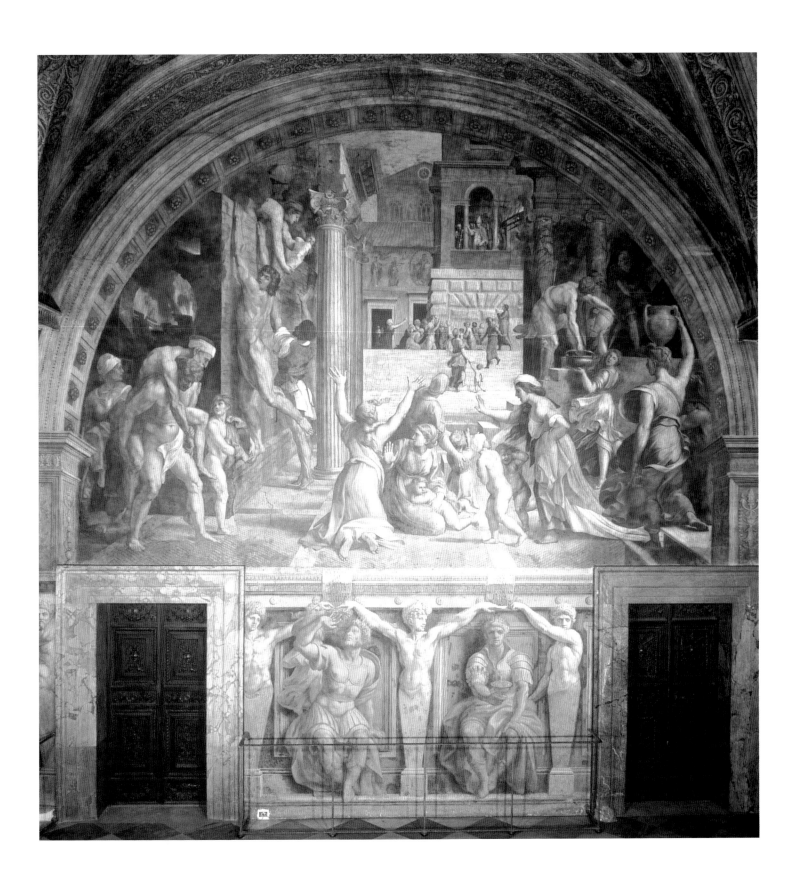

The four histories, all of which illustrate scenes from the lives of two earlier Popes with the same name as Leo X, Leo III and IV, differ from each other as they draw upon different compositional schemes. The *Fire in the Borgo* is an inventive reworking of a widely-used late Quattrocento formula in which foreground figures are set in a recognisable architectural setting. In the examples that Raphael would have known (Ghirlandaio's frescoes in SS. Trinità, Florence, for instance) the action is concentrated in the foreground, but in the *Fire* the central figure, the blessing figure of the Pope, is in the background. According to the *Liber Pontificalis* Pope Leo IV quenched a fire that had broken out in the Borgo di San Pietro by giving the sign of blessing. Raphael's brilliant invention of the composition enables him to contrast the drama of the fire in the foreground with the calm response of the Pope, on whom attention is focussed by the gesturing woman with her back turned to the spectator nearly in the centre of the composition as well as by the small figures running to the Pope. The setting is established by the view of Old St. Peter's in the centre of the fresco but Raphael has taken liberties with the architecture placing the Pope in a tower whose lettering helps to identify him and also the building for which he was responsible although its relationship to Old St. Peter's has been modified; the fire is seen flickering in the background through an arch in a wall that runs behind a broken entablature supported by columns reminiscent of the remains of the Temple of Vespasian in the Forum.

Raphael uses another device to ennoble the Borgo, for the group of the young man carrying an older one on his back as they escape from the fire recalls Virgil's account of Aeneas rescuing his father Anchises from the flames of Troy, an example of pietas which is given further point by giving Anchises the features of Cosimo de' Medici, pater patriae, the founder of the fortunes of the house of the Medici, the Pope's family. Raphael achieves a new gracefulness in the mothers with their children and in the girl on the left carrying a jug of water on her head; she is a reworking of a motif, long popular in the Renaissance, whose robes, inspired by classical wet-look drapery, admirably suggests the power of the wind blowing from the right of the fresco.

The handling of the light and shade in the group of Aeneas and Anchises links with that of earlier nudes, the executioner in the *Judgement of Solomon* for instance, although the new muscularity of the figures is testimony to Raphael's continued interest in Michelangelo; the quality of the execution, both of the details and of the whole composition contrasts with the other frescoes in the room which must have been carried out in large part by the workshop. None of the nudes brought before the seated figure of Pope Leo IV in the *Battle of Ostia* match the group of Aeneas and Anchises and the overall frieze-like grouping, which develops from that of the *Repulse of Attila*, is broken by the boatman on the right who tips awkwardly into the spectator's space.

AENEAS AND ANCHISES, DETAIL, FIRE IN THE BORGO

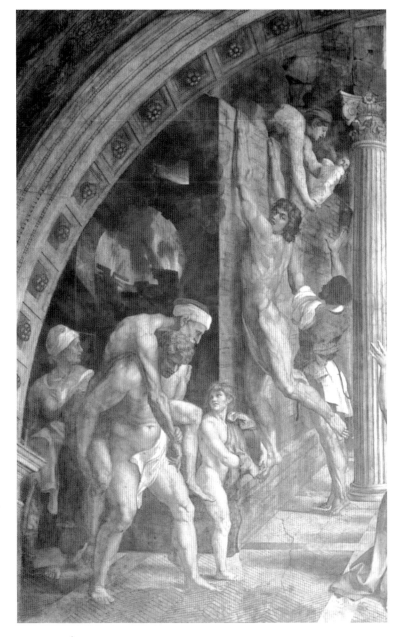

The battle which can be seen raging outside the gates of Rome's sea-port, Ostia, had taken place in 849. when the Saracens had been defeated by troops under Pope Leo IV; the successful outcome of the engagement is underlined by the action in the foreground, where as in many Roman reliefs, captured Saracens are brought to submit before the seated Pope who looks up in prayer to Perugino's God the Father in the ceiling. Both the frieze-like grouping of the foreground figures and many of the individual motifs derive from classical reliefs. The unity of the composition achieved in the soldiers in the centre of the fresco who reach over a group of three fallen soldiers to grab the hair of a Saracen who has just got off the boat testifies to the continued influence of Michelangelo's *Battle of Cascina* which introduced a comparable interlinking.

Sea battle at Ostia

Stanza dell' Incendio, Vatican

Palace

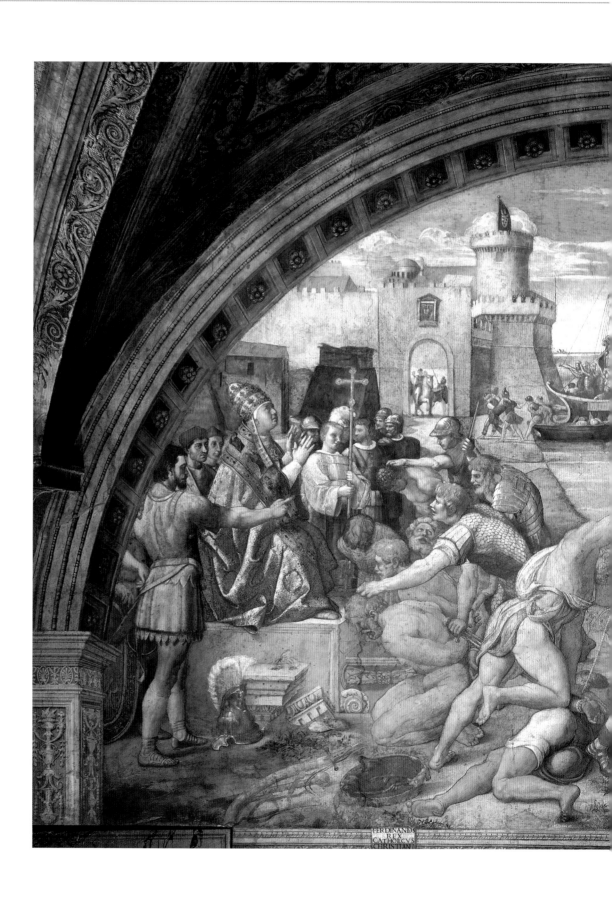

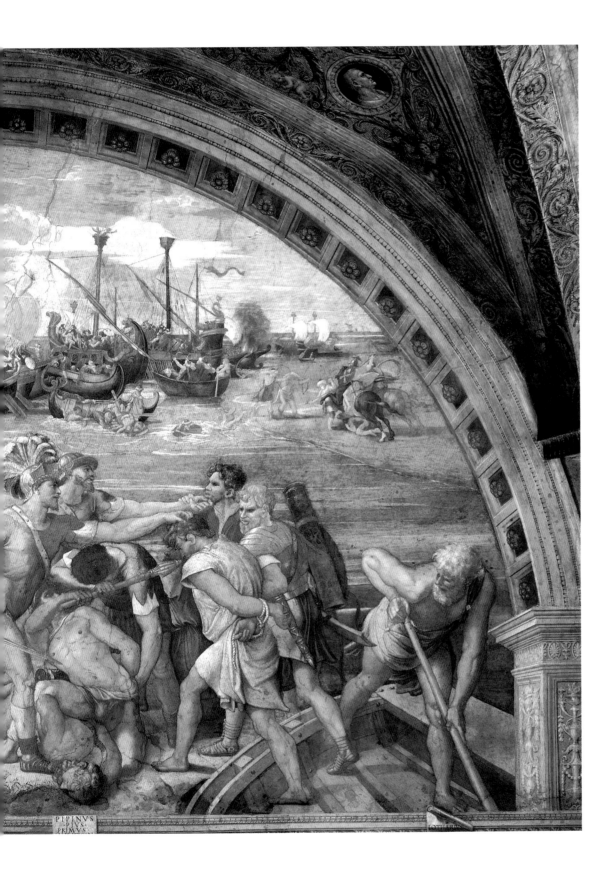

The pointing soldier on the left of the Pope's throne has been developed from the nude study that Raphael sent to Dürer in 1515 (page 31), because of his appreciation of his prints, some of which he is said to have kept pinned up on the walls of his studio. Enthusiasm for Dürer and for other northern print-makers was widespread in the early years of the sixteenth century but Raphael's interest was exceptional in that, unlike his younger contemporary Andrea del Sarto in Florence, he was influenced by the composition of the prints rather than the exotic details of headgear and costume. The *Coronation of Charlemagne* below is a case in point because in his search for a scheme that would cope with the asymmetrical door on the left, which is more intrusive than that in the *Disputà*, he turned to Dürer's woodcut of *Christ before Pilate*

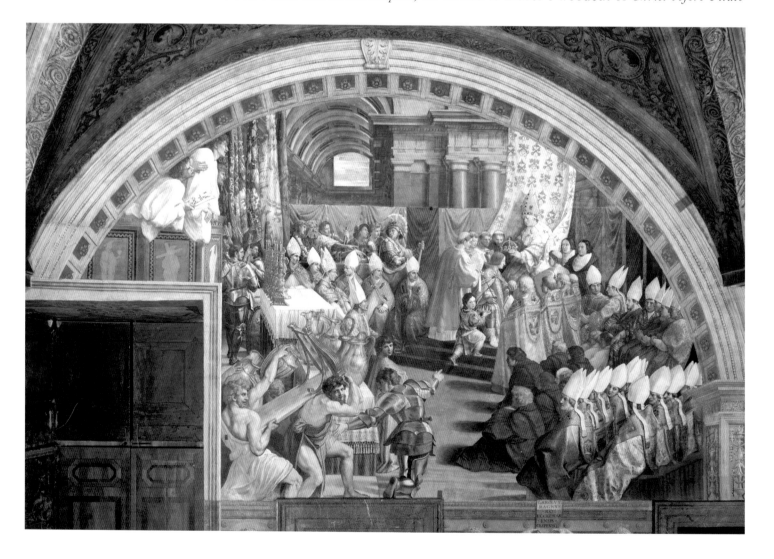

in the Small Passion, which makes use of a complex play of levels with Pilate raised up on a flight of steps in the background, Christ lower down on the left and his accuser raised up in the foreground. Raphael has taken over the high viewpoint it is set (at about the level of the Pope's head) so that we look down at the rising floor of the church and the cardinals and up at the underside of the arches. The asymmetry of the design gives the composition a boldness and an energy that is not found in a comparable earlier composition with which Raphael would have been familiar, Pintorricchio's *Coronation of Pope Pius II* in the Piccolomini Library, Siena.

The final fresco in the room, the *Oath of Pope Leo III* which is duller in reproduction than in the actual fresco, looks back not so much to the *Mass at Bolsena* as to the first design which is known through a copy in the Ashmolean Museum, Oxford, which was a more suitable model for it allowed the inclusion of the large number of (mostly unidentifiable) contemporary spectators who watch while Pope Leo III swears a solemn oath in the centre of the fresco. The moment is less dramatic than in the *Mass at Bolsena* and this change is reflected in the ceremonial character of the fresco with the dignified spectators on the platform above the steps who stand in a curve which sweeps slowly through the central figure of the Pope, who is impersonated by Leo X.

The contemporary reference is underlined by the inscription underneath the fresco which reads: 'DEI NON HOMINUM EST EPISCOPOS IUDICARE' ('God and not man is the judge of bishops'). The phrase, which is taken from the Bull 'Unam Sanctam' of Pope Boniface VIII, formed part of the assertion of Papal independence from secular power which Pope Leo X had promulgated at the Lateran Council late in 1516. In this context it is not surprising that the six seated princes of the dado (Constantine, Charlemagne, Godfrey de Bouillon, Astolph, Ferdinand, Lothair and Pippin, who has been destroyed) were all defenders of the church, and the defence of the church inspired the choice of subject of both the Battle and the Coronation. In the latter fresco Pope Leo X is depicted as

OATH OF POPE LEO III

FRESCO DETAIL

Stanza dell' Incendio,

Vatican Palace

Pope Leo III while Charlemagne has the features of Francis I of France, the French King who had signed a treaty with Pope Leo X in October 1515 in which he undertook to defend the church, a moral which is underlined by the inscription which links the fresco with the portrait of Charlemagne underneath: 'CAROLUS MAGNUS RO. ECCLESIAE ENSIS CLYPEUSQUE' ('Charles the Great of the Romans [i.e. Charlemagne] sword and shield of the Church').

The ships in the background of the *Battle of Ostia*, which are carefully arranged on a restricted diagonal, are not based on classical ones, with which Raphael would have been familiar from Trajan's column, but are modern vessels, which underline the contemporary message of the Pope's upturned gaze, as he looks for inspiration for the crusade against the Turks which was one of his main political aims. The flames that the Pope quenches in the *Fire in the Borgo* may allude to the rival council set up by schismatic cardinals (to which the frescoes in the previous room referred) which Pope Leo X had brought to an end or, more plausibly, to the flames of war which he had successfully put out in his capacity as the bringer of peace to Italy.

The *Sala di Costantino*

Leo X intended to continue this theme in the last of the suite of rooms, the large public 'aula pontificum superior', the *Sala di Costantino*, which was used for feasts and receptions. The decoration was begun under Leo X to designs which Raphael had prepared before his death on 6 April 1520.

Four scenes from the life of the first Christian emperor, Constantine the Great, were to frescoed on great illusionistic tapestries, apparently suspended from the cornice and curling round at the ends where they were framed by early Popes, with their accompanying virtues. Leo's scheme celebrated him as a second Constantine, defeating the impious, under the inspiration of the cross, while displaying his generosity to captured troops and to young children, whose blood was to have been used in the bath to heal the ailing Emperor. The scenes included the *Battle*, the *Vision*

View of *SALA DI COSTANTINO*

Vatican Palace

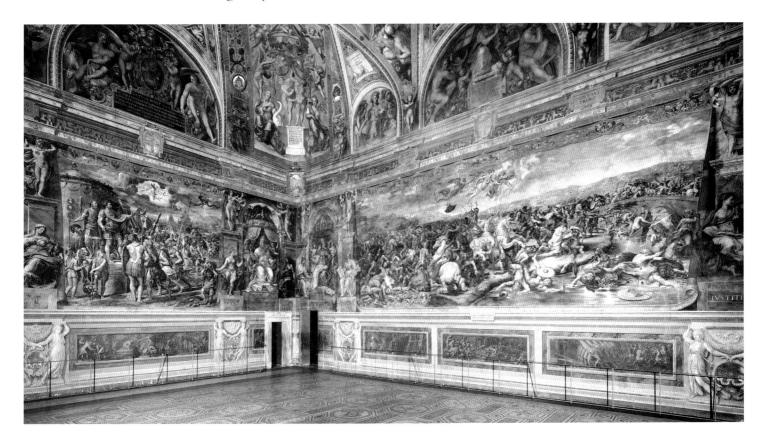

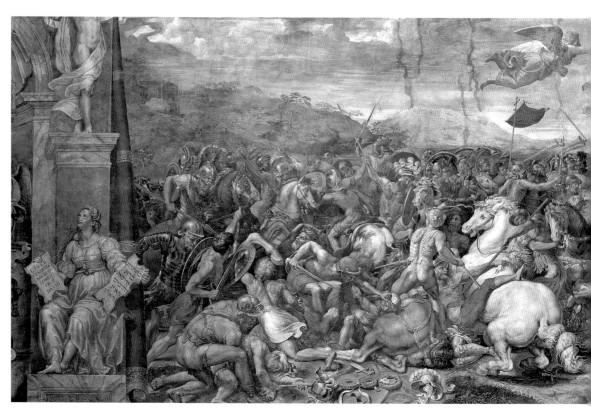

of the True Cross (both of which were executed) the *Procession of the Prisoners* and the *Preparation for Constantine's Cure in a Bath of Blood*. The scheme was completed under the next Medici pope, Clement VII, when the latter two scenes were replaced by the *Baptism of Constantine by Pope Sylvester* and *Constantine's Donation to Sylvester*. The initial programme reflected humanist hyperbole, of the kind which Blosius Palladio had prepared in his speech to celebrate the dedication of Leo's statue on the Capitoline.

By 1523 these comparisons were no longer tenable. The election of the leading member of the Hapsburg family as the Emperor Charles V had alerted Italy to the presence of a new power, whose control stretched from Naples in the south, through its claims on Milan, to the Netherlands and to Spain. In view of the renewed glamour with which Charles invested the Holy Roman Empire it must have seemed prudent to change the programme of the *Sala di Costantino* to one which emphasised both the spiritual and the temporal rights of the church. According to the 'Donation of Constantine' the emperor

Battle of the

Milvian Bridge

Sala di Costantino, Vatican Palace

granted Sylvester I rights to 'the city of Rome and all the provinces of Italy and the western regions', claims which were in need of restatement during the Papacy which saw the Sack of Rome only four years after the completion of the *Sala di Costantino*.

The range of sources on which Raphael drew for the *Battle of Milvian Bridge* reflect both Leo's concern to appear as a second Constantine and the breadth of Raphael's knowledge of the antique. The Milvian bridge on the right establishes an authentic setting for Constantine's decisive victory over Maxentius in 312, which is echoed in the topographically accurate view of the Monte Mario. The composition and Constantine riding a white horse in the centre, while trampling his foe under foot, were inspired by the great Trajanic frieze on the Arch of Constantine. The massing of the army behind Constantine, with its emphasis on the round and straight trumpets, resembles Trajan's column, the source for many details, including the riders who hold out the heads of their defeated opponents to the Emperor. These were not taken wholesale, but their poses were then restudied from models in the studio.

The Tapestries for the Sistine Chapel and their Cartoons

The *Stanza dell' Incendio* and the *Sala di Costantino* formed part of the Pope's private suite of rooms, and this is reflected in the choice of Leo as hero. This is in contrast with the more public and general nature of Leo X's commissions for the *Logge*, and the series of ten tapestries for the Sistine Chapel. These were woven by Pieter van Aelst in Brussels from Raphael's cartoons, for which Raphael received payments in June 1515 and the end of 1516, and were first hung in the Chapel at the end of 1519. After the Papacy's return from exile in Avignon the Vatican assumed a renewed importance and under Pope Nicholas V (1447-55) it, rather than the Lateran which had previously been the home of the Bishop of Rome, housed the Pope and the large retinue of the Curia. The Sistine Chapel completed a part of the Vatican's defences but it was also intended as a Renaissance example of 'magnificenza' in building and as such may have been intended to rival the buildings of Solomon, the greatest builder of the Old Testament, as well as the Ark that carried Noah to safety.

By 1483 Perugino, Botticelli and other, mostly Tuscan, artists had undertaken the first stage of the decoration of the chapel with a series of frescoes based on the Life of Christ), which ran above the altar on the right hand side (assuming that the spectator stands with his back to the door facing the altar) and which was matched by a comparable series of scenes from the Life of Moses on the opposite side. Above the narrative frescoes, framing the windows, was a series of Popes which may have begun on the altar wall with Christ in the centre, and underneath, in the area covered by Raphael's tapestries were illusionistic hangings. The choice of Moses and Christ, the outstanding leaders of the Old and New Testaments, whose scenes were coupled typologically, illustrated the primacy of the Papacy.

Between 1507 and 1512 Michelangelo transformed the chapel with his great ceiling which replaced the original design by Piermatteo d'Amelia of stars set on the blue

vault of heaven. The great structure of Michelangelo's ceiling both endorses the previous decoration and superimposes an architectural framework of unprecedented weight and grandeur. The original commission was for a series of seated apostles, who would presumably have been accompanied by scenes from their lives. Michelangelo changed this to an Old Testament cycle running from the *Separation of Light* over the altar to the *Drunkenness of Noah* over the entrance. This sequence adopted the same narrative order – from the altar to the entrance – as Quattrocento cycles, and took account of the division of the chapel by the screen, although this was later moved nearer the entrance. Michelangelo's scheme complemented the narrative subjects by showing the history of the world before the coming of God's law ('Ante Legem'), the Moses cycle then showed the world under the law ('Sub Lege') and the Christ cycle the period of Grace ('Sub Gratia').

Leo X's commission for tapestries of scenes from the lives of SS. Peter and Paul continued the affirmation of papal primacy of the Moses and Christ cycles, as well as stamping his own personality on the chapel. The richness of the material and expense of having them woven in Flanders makes the tapestries an example of Medicean 'magnificence', recalling his family's banking connections with Flanders in the previous century and their patronage. This established a frame of reference, very different from that of the artists working for either Sixtus IV or Julius II, especially in view of Leo's encouragement for Raphael's growing antiquarian interests. Leo demanded scenes illustrating his life, which were included in a mock bronze basamento, under the apparently solid frames of the main scenes. For all the difference in scale each tapestry thus came to resemble the intricate borders of Renaissance miniatures. Such a model, although not new, must have appealed to the patron whose portrait by Raphael shows him with one of the illuminated manuscripts from his collection

SS. Peter and Paul had been linked by long-established tradition, most recently in Filarete's bronze doors for St. Peter's, from the middle of the Quattrocento. Raphael greatly extended the narrative of the tapestries to show the calling of SS. Peter and Paul and their missionary and healing activities. The tapestries began on the altar wall: the sequence for the Peter cycle is: *Miraculous Draught of Fishes The Charge to Peter Healing of the Lame Man The Death of Ananias* and for St Paul: *Stoning of St. Stephen The Conversion of Saul The Conversion of the Proconsul Sergius Paulus The Sacrifice at Lystra Paul in Prison Paul at Athens.* The histories are set inside narrow mock-stone frames with borders at the side and underneath; the lower ones are restrained in colour (in contrast with the histories) and emulate Roman reliefs with their own thin frames. The subjects combine further episodes from the Acts of the Apostles with scenes from the life of Giovanni de' Medici. The borders include *Hercules*, the *Four Elements*, the *Liberal Arts* and the *Cardinal Virtues*.

The Petrine cycle hung on the right, under the quattrocento *Life of Christ* and opposite the enthroned Pope, and the Pauline on the left. The altar was then framed by the *Stoning of St. Stephen* and the *Miraculous Draught* and St. Stephen in the tapestry of the *Stoning* kneels in adoration of God the Father and of the altar. The group of men stoning him was continued in the horsemen on the way to Damascus in the *Conversion of Saul*, a connection that is echoed in the line of the mountains in both tapestries. One of the boats weighed down with the catch in the *Miraculous Draught* is anchored to the left of the *Charge to Peter*, in the tapestries but not the cartoons. Raphael had taken account of the reversal in the weaving, and had taken at least one offset to enable him to judge the effect of the reversal.

The cartoons must have been sought-after for one, for the *Conversion of Saul*, was one of the sights of the Grimani collection in Venice almost as soon as the tapestries were displayed in the Sistine Chapel; those now in the British Royal Collection (on extended loan to the Victoria and Albert Museum, London) were acquired from Genoa by Charles I in 1623 and are one of the rare parts of that collection to have survived the

Commonwealth (the other notable survivor is the Mantegna *Triumph of Caesar* series) to play an important part in the shaping of English eighteenth-century taste.

Critics then regarded the cartoons as the ultimate embodiment of the Grand Style, superior even to the frescoes in the *Stanze*; for long this enthusiasm was not shared by modern critics but the restoration of 1966 set the seal on a revised estimate of their quality and further revealed the considerable accomplishment of the cartoons. Many of the heads, that of the mother about to give suck to her child in the *Healing* (page 106) for instance, are of a quality that can only be attributed to Raphael, not to his workshop, while others, the clumsy and inexpressive arm and head of the lictor to the left of the Proconsul Sergius Paulus in the *Conversion of the Proconsul* (page 110), are much more awkward. X-rays of the blocking-in of the figures show that more than one hand was at work; in a number of cases, however, the changes between the blocked-in head and the cartoon reveal a rise in the quality of the execution in terms of the artist's ability to combine a solid three-dimensional figure with a control of light and an incisive depiction of character, underlining Raphael's role in their execution.

The *Miraculous Draught* illustrates the passage in Luke 5, 3-10, when at Christ's urging Peter and his companions took their fishing boats on the lake of Gennesaret and to their surprise 'they inclosed a great multitude of fishes' (they had fished all night in vain) so that Simon Peter knelt before Christ who responded: 'Fear not from henceforth thou shalt catch men'. Raphael has reworked his model, Ghirlandaio's fresco of the *Calling* in the Sistine Chapel, in the light of the text and achieved in his grander and more monumental style a unified movement (which is clearer in the tapestry than in the cartoon). This begins with the old seated boatman in the second boat and the two apostles struggling with their nets is continued through the standing figure in the next boat and the kneeling Peter and ends in the blessing figure of Christ. The weight and scale and Raphael's figure style is matched by a new naturalism and love of detail, the swans between Christ and Peter, the cranes in the foreground, an emblem of watchfulness, treated with striking realism as are the catch and the reflections in the calm surface of the lake.

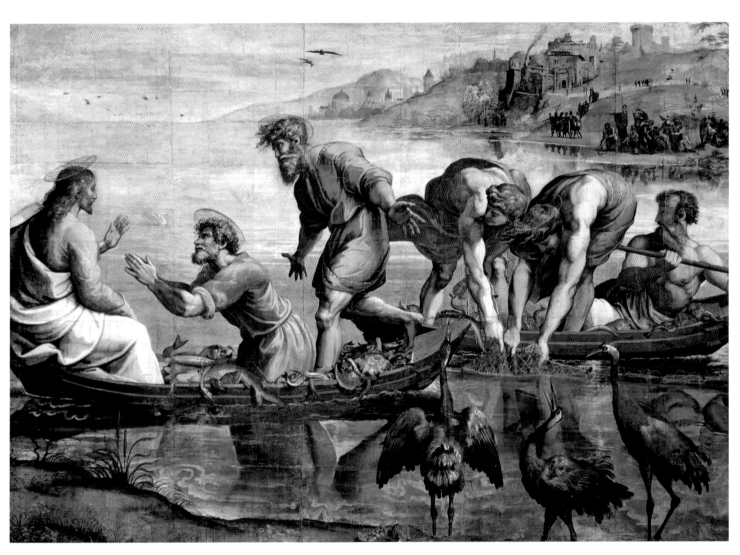

THE MIRACULOUS

DRAUGHT OF FISHES

Her Majesty the Queen, on loan to

the Victoria and Albert Museum

Body colour on paper, 320 x 390 cm

The second of the cartoons, the *Charge to Peter*, combines two texts; the main source is John 21, 1-17, which sets the scene by the Sea of Tiberias and establishes this as one of Christ's appearances to the apostles in the period after his Resurrection and before the Ascension (hence his white robes picked out with gold in the tapestry, the costume he is traditionally shown wearing in this period) when after supper Jesus questioned Peter and charged him with the injunction 'Feed my sheep'. The keys that Peter clutches refer to the earlier moment when Christ set him above the other apostles with the phrase: 'And I will give unto thee the keys of the kingdom of heaven' (Matthew 16, 16 ff.). The kneeling St. Peter is isolated in front of his surprised companions to whom he is linked by their gestures and the device of setting another

apostle who stands some way back from Christ with his robes trailing on the ground in the same plane. The prototype for this monumental group was Masaccio's *Tribute Money* in the Brancacci chapel in the Carmine, Florence. Raphael has reworked his model with a new vitality, in part achieved by the brilliant range of colour as in the other cartoons, and the unified movement which is based upon the contrast between the six heads seen in profile with the remainder. The movements of the group are also carefully contrasted with the youthful St. John eagerly rushing forward, and the relationship of the figures to the landscape is a reworking of that of the *Entombment*, (page 56) enlivened by fresh observation in the plants in the foreground and the house under the tower with the washing hanging on its line.

THE CHARGE TO PETER
Her Majesty the Queen, on loan to the Victoria and Albert Museum
Gouache on paper, 342 x 536 cm

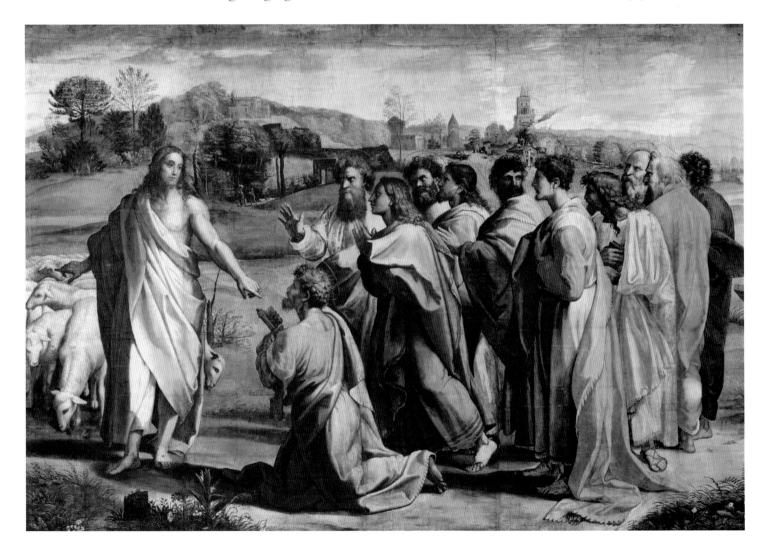

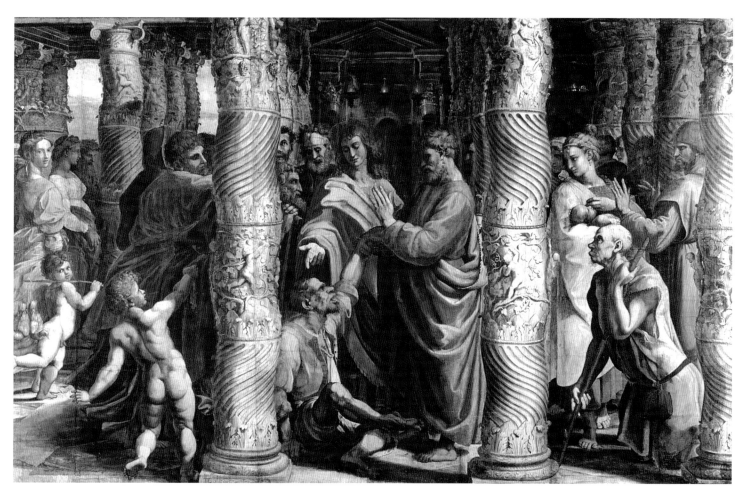

The *Healing of the Lame Man* illustrates the passage in Acts 3, 1-11, where Peter and John on entering the Temple by the doorway called 'Beautiful' were accosted by a lame beggar who they healed in the name of Jesus Christ. The story ends: 'All the people ran together unto them [Peter, John and the lame man] in the porch that is called Solomon's' thus linking the *Porta Speciosa* with Solomon's porch and providing the inspiration for Raphael's use of the twisted late Roman columns decorated with vine motifs. The set of twelve had been given to St. Peter's by Constantine the Great, a provenance that had long been remembered, but by Raphael's time they were believed to have come from Solomon's Temple at Jerusalem. There was a well-established tradition which showed the Temple as an arcaded building with columns continued in depth; in Giovanni da Milano's fresco of the *Expulsion of Joachim* in the sacristy of S. Croce, Florence, the architecture is an idealised Gothic and the same structure was

taken over but modernised by Ghirlandaio in his frescoes in the choir of S. Maria Novella, Florence. Raphael's setting belongs to this tradition but by eliminating the capitals and cornice in the foreground relates the Temple much more effectively to the monumental apostles in the centre.

The *Death of Ananias*, the last in the Petrine series, illustrates both Acts 4, 34 ff., with members of the church bringing the proceeds of the sale of their property to the apostles by whom it is redistributed on the left of the cartoon, (the right and end of the tapestry) and Acts 5, 1-5, with the death of Ananias accused of cheating by St. Peter. The decision to raise St. Peter and the other apostles on a wooden platform, whose nails are carefully shown, must have been inspired both by the text which describes those who had sold their belongings as laying their money at the feet of the

THE DEATH OF ANANIAS

Her Majesty the Queen, on loan to

the Victoria and Albert Museum

Gouache on paper, 342 x 530 cm

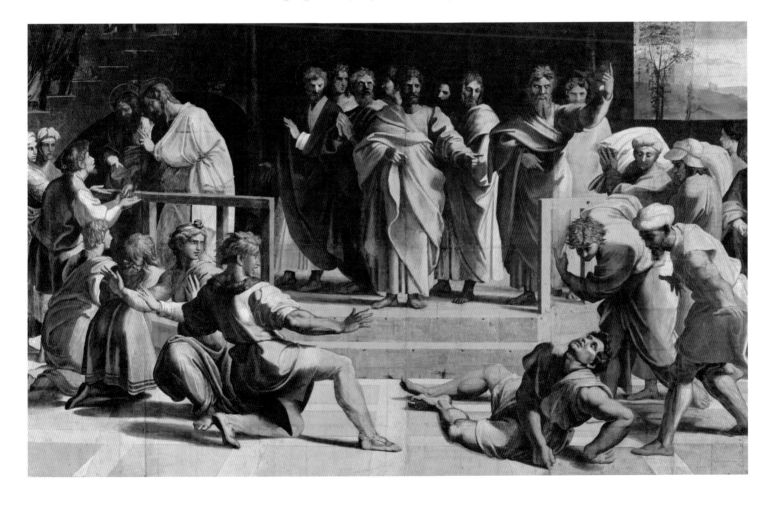

apostles and by the complex levels used by Dürer in his woodcuts of the Small Passion, notably the *Christ before Pilate*. It has been suggested that the composition was influenced by the Constantinian *Oratio Augusti* relief on the Arch of Constantine where the Emperor on a raised platform addresses the spectator directly. The effect is very different and this is a most unlikely source in view of Raphael's letter on the antiquities of Rome of 1519, where he singles out these reliefs as the start of a long period of decline: 'The composition of the architecture of the Arch of Constantine is beautiful and well made but the reliefs of the same arch are extremely tasteless, with no art or good design.' Raphael's enthusiasm for monumental antique figures is

CONVERSION OF ST. PAUL

Vatican Museum

Tapestry

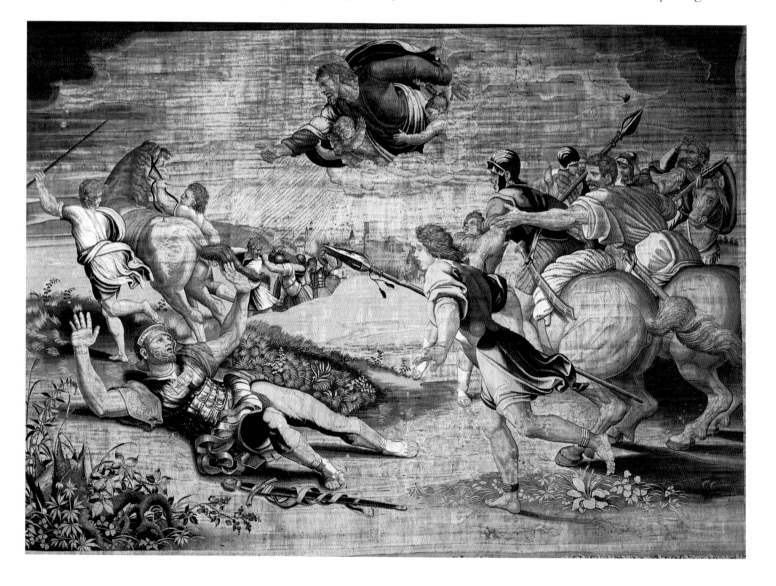

demonstrated in the massive Ananias writhing in agony whose pose is an imaginative reconstruction of a *Dying Gaul* now in Naples which Raphael knew in Rome when it still lacked its head and left arm.

St. Peter and the apostles around him refer back once more to Masaccio's *Tribute Money* and the composition of the *Stoning of St. Stephen*, which is known only in the tapestry, looks back to the fresco of this subject at Prato by Masaccio's closest follower, Filippo Lippi. Lippi's version is placed in the same relationship with the altar so that the kneeling Stephen responds to the vision of the Son of Man standing at the right hand of God, Acts 7, 55-59, begs clemency for his executioners and also adores the altar. Raphael's executioners take on a new and very obviously Michelangelesque weight which is echoed in St. Paul, who sits with their robes at his feet urging them on in a dramatic pose that recalls the ignudi of the Sistine ceiling.

There was also a well-established pattern for the next in the Pauline series, the *Conversion of St. Paul*, the cartoon for which, as we noted, was in the Grimani collection in Venice in the 1520s. Raphael followed this earlier tradition in his illustration of Acts 9, 3-7, most notably in the fallen figure of Paul blinded by the light as God the Father appears to him. The changes are even more instructive: the contemporary armour has been changed for Roman, and the horses which are shown in the background are here brought into the foreground and shown in motion on the model of Leonardo's *Battle of Anghiari*, an innovation that affected most later versions of this subject.

Blindness also plays an important part in the next of the tapestries, the *Conversion of the Proconsul* which illustrates Acts 13, 6-12. The cartoon, which has been cut down omitting the pier at Paul's side with a classical statue in the niche, was long known as the *Blinding of Elymas*, the sorcerer at the court of the proconsul Sergius Paulus, but the inscription on the throne: 'SERGIUS PAULLUS ASIAE PROCOS CHRISTIANAM FIDEM AMPLECTITUR SAULI PREDICATIONE'

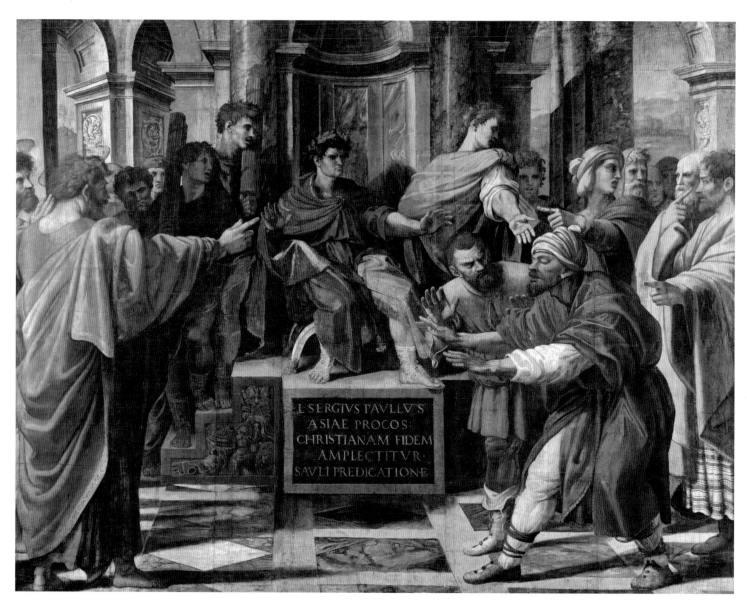

THE CONTENT OF THE STONE TABLET:

L SERGIVS PAVLLV S
ASIAE PROCOS:
CHRISTIANAM FIDEM
AMPLECTITVR
SAVLI PREDICATIONE

THE CONVERSION OF THE
PROCONSUL SERGIUS PAULUS
Her Majesty the Queen, on loan to
the Victoria and Albert Museum
Gouache on paper, 340 x 450 cm

('Sergius Paulus, Proconsul of Asia is converted to Christianity by the preaching of Saul') underlines that the blinding of the sorcerer was a means to the conversion of the Proconsul just as the Saul's own blindness in the previous tapestry had lead to his conversion. Classical reliefs showing a seated Emperor raised up to receive homage or distribute gifts inspired the composition which has been transformed into a pyramidic structure with the proconsul's head at its apex. Raphael has taken care with the

archaeological details, the bundles carried by the lictors, the complexity of the proconsul's sandals by contrast with the simple footware of the apostles, his throne, the laurel wreath in his hair and the relief of trophies set into the steps based upon the pillars then outside S. Sabina, now in the Uffizi; the complex but irrational architecture (it defies description in a ground plan) is a monumental reworking of a type much used by Ghirlandaio in his Florentine frescoes and the massive pointing Paul on the left of the cartoon is derived from the frescoes of the Brancacci chapel in S. Mario de Carmine, Florence.

The archaeological care so notable in the *Conversion* recurs in the two final cartoons and in the small tapestry of *St. Paul in Prison*. The earthquake that freed St. Paul is represented through the massive Oceanus breaking the ground under Paul's prison and some of the frame. He was derived from the figure supporting Jupiter's throne in the relief of the Judgement of Paris. The *Sacrifice at Lystra* illustrates Acts 14, 8-18; Paul and Barnabas cured a cripple and were hailed as gods (comparing Paul with Mercury because of his eloquence, hence the statue of Mercury in the background of the cartoon) for whom a sacrifice was prepared which Paul persuaded them to abandon.

Such a text challenged Raphael's knowledge of the Antique and the cartoon reveals his deep study of Roman sacrifice reliefs. The central group of the priest, naked to the waist with his axe upraised about to strike the bull, whose head is held down by a kneeling attendant, comes from one such relief as does the small boy playing the twin pipes. Other reliefs were used for further details, the second boy holding a casket, the belt worn by the priest and the bull in the background. The healed cripple joins his hands in prayer to his new gods, whilst the bearded spectator on the right edge underlines the miracle by looking down at the crutches at his feet. The gesture of prayer is linked with the young man leaning across the sacrificial bull to draw the priest's attention to Paul and so to stop the ceremony.

THE SACRIFICE AT LYSTRA

Her Majesty the Queen, on loan to

the Victoria and Albert Museum

Gouache on paper, 342 x 536 cm

The final cartoon, *St. Paul at Athens*, illustrates the account of his preaching in Acts 17, 16-31, when after disputing in the synagogue with the Jews they took him to Areopagus where he 'stood in the midst of Mars's hill and said, Ye men of Athens I perceive that in all things you are too superstitious...'; Mars's hill is characterised by the statue of Mars seen from behind and set outside a round temple which with its Doric order and low drum supporting the dome (only the base of which can be seen) is clearly modelled on Bramante's Tempietto in S. Pietro in Montorio, Rome. That Doric was suitable for a male god like Mars was a commonplace of later Renaissance architectural theory, but was first applied by Bramante. Raphael recognised this in his letter to the Pope on Rome. After the Goths came modern architecture: 'So that in our day architecture has revived and has come fairly close to the ancient style, as can be seen in the many beautiful works of Bramante, nonetheless the ornaments are not of such precious materials as in ancient buildings.'

The design takes account of the reversal and of the intended position outside the chancel screen so that the laity are associated with the doubtful Athenians listening to the saint. The steps on which he is raised derive, like other spatial tricks used by Raphael from Dürer's *Christ before Pilate* from the Small Passion, as does the long cap with which Raphael decks out Pope Leo X (he can be compared with the life bust of him as cardinal which is placed besides the cartoon). The breadth of classical sources used in the tapestries was prompted by a range of factors: Leo's concern to outdo the della Rovere; Raphael's paragone with Michelangelo and with the chapel's quattrocento frescoes, and his antiquarian scholarship. The rich surfaces of the tapestries were recreated with dazzling effect in Raphael's designs for the *logge*, intended to rival those of antiquity, and in the frescoes of the *Sala di Costantino*, celebrating Leo as a second Constantine

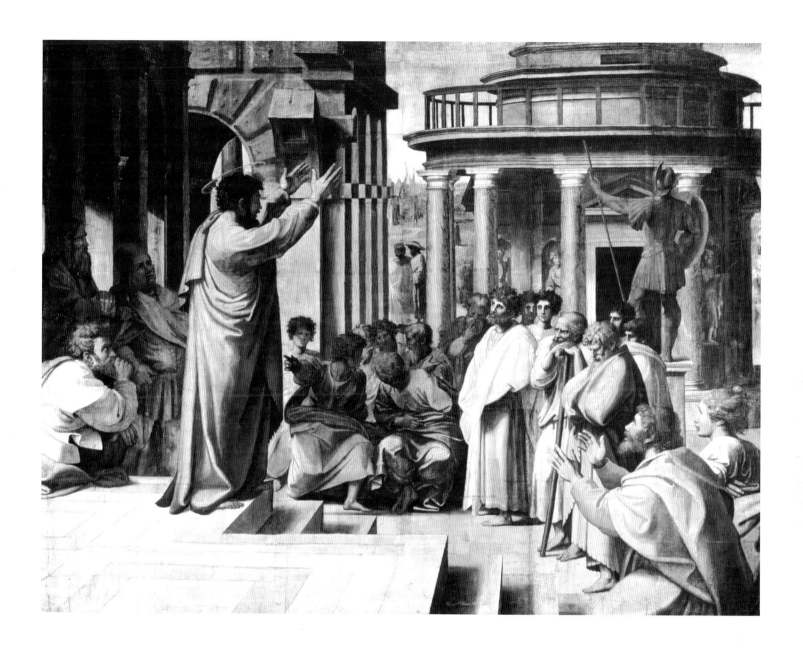

THE *LOGGE*

Villas with ground-floor *logge* affording views onto the countryside had been developed in Florence, Rome and Naples in the early 1480s as a response to the descriptions (most notably those of Pliny the Younger) of the views commanded by the villas of antiquity. It is one aspect of Bramante's imaginative genius that he developed this into a three-storey *loggia* running the length of the Belvedere Cortile in

the great plan that he evolved as a response to the commission to connect Pope Innocent VIII's Belvedere Villa on the Mons Vaticanus with the Vatican Palace. He had also begun a comparable loggia as a facade for the Cortile di San Damaso, the approach to the Vatican palace seen by a visitor approaching St. Peter's. Raphael completed this three-storey loggia, adding a decoration of stucco and fresco which illustrates his view that Bramante's architecture was nearly as good as the Antique: 'nonetheless the ornaments are not of such precious materials as in ancient buildings'. Such is the richness of the decoration of the thirteen bays of the *Logge* that the complete photographic survey involves the largest single volume on any one enterprise by Raphael and his workshop; each of the thirteen bays has richly variegated decoration on the columns which mix stucco with frescoes in a brilliant recreation of the grotesque style of the *Domus Aurea of Nero* which is combined with a striking Flemish-inspired naturalism in the plants, animals, fish and landscape.

ISAAC AND REBECCA

Logge, Vatican Palace

The stuccoes on the arches of the bays alternate rectangles with small squares, based on a now-lost decoration on the inside of the Colosseum, while the low vaults contrast a large central square with four histories. In some bays, the third is an example, the histories are set against an illusionistic colonnade which appears to extend the architecture and run behind the curving frames of the histories. This illusion is much more successfully worked out in the southern bays' which suggests that, like the Sistine Ceiling, the *Logge* were painted in an order which reverses the narrative which runs from the Creation through a series of Old Testament scenes to end with Solomon, the church's great builder and Christ (*Birth, Adoration of the Magi, Baptism of Christ, Last Supper*). In other bays, the seventh with scenes from the *Life of Joseph* for example, the decoration acknowledges the curves of the vault which it covers with a rich decoration based upon classical relief.

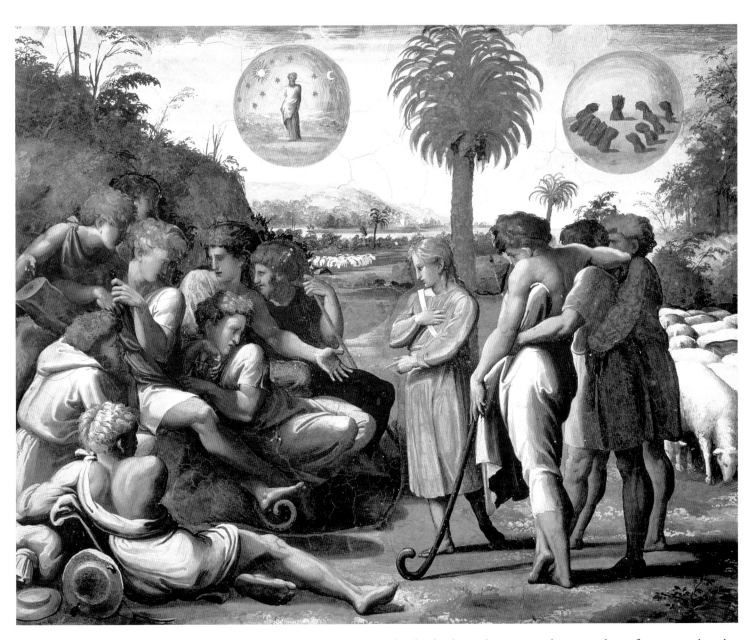

This is the central bay around which the scheme revolves so that, for example, the decoration of the sixth and eighth bays correspond as do the others leading to the first and thirteenth. The care with which the scheme was planned reveals Raphael's overall responsibility, but at this stage of his career a work of this scale could not expect his personal intervention as an executant. From the time of Vasari onwards the game of guessing which member of the workshop was responsible for individual histories has developed into one of the dreariest of modern art-historical industries. There can be no

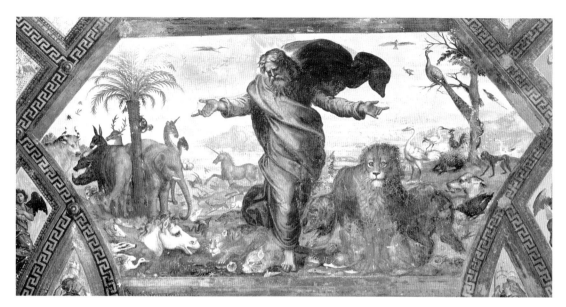

THE CREATION
OF THE ANIMALS
Logge, Vatican Palace
Fresco

doubt that the narrative frescoes reveal a wide range of hands but we are not in a position to form a clear picture of the individual members of Raphael's workshop at this period and, just as important, the emphasis on story-telling reveals the impact, however indirect, of the priorities that we have traced in Raphael's other great enterprises.

It is for this reason that the frescoes of the *Logge* have become known as 'Raphael's Bible', a name which does justice to their continued impact on later artists in search of effective narrative formulae. One example from among the 92 scenes must serve: the *Isaac and Rebecca* illustrates the climactic moment of Genesis 26, 6 ff. after the drought had driven Isaac and his wife to stay with Abimilech, the King of the Philistines at Gerar. Doubtful of his reception Isaac had lied about his relationship with Rebecca whom he described as his sister, a relationship that was accepted until Abimilech caught Isaac: 'sporting with Rebecca his wife' which lead somewhat surprisingly to Isaac's prosperity. The furtive nature of the embrace is suggested in the way the husband and wife perch awkwardly on a ledge, while above them King Abimilech peers down over a window; the combination of the hurried embrace and the spying figure above caught Rembrandt's imagination (he knew the design through an engraving) and is shown in a rapid sketch in a private collection in New York which became the basis for the so-called *Jewish Bride*.

ALTARPIECES

Raphael's success in the service of the Papacy left him relatively little time to work for outsiders. In 1511, for instance, Duke Alfonso d'Este of Ferrara planned to decorate his new studiolo in the ducal palace with marble reliefs and a series of paintings illustrating the power of love and wine. The individual scenes were drawn from Philostratus, Ovid and Catullus. The combination of reliefs and paintings, by the most famous artists of the period, was intended to emulate the palace described at the opening of Philostratus' *Imagines*, which Alfonso had borrowed from his sister Isabella. Alfonso began with Giovanni Bellini's *Feast of the Gods* and sought commissions from Fra Bartolommeo and Raphael. Titian only became involved after Fra Bartolommeo's death and the failure of the duke's agents in Rome to obtain a painting from Raphael, who by 1517 sent a finished drawing of *The Indian Triumph of Bacchus*. Bacchus, to judge from the eighteenth-century facsimile of a studio drawing, rode in triumph, accompanied by an Indian princess, almost dwarfed by the elephants and camels in the background. The two-tiered composition and details including the slumped Silenus riding a lion, the dancing maenads and the figures riding exotic animals resemble Roman sarcophagi of Bacchus' Indian triumph, in a design carefully tailored to fulfil Alfonso's interest in exotic animals, in this case Leo X's elephant, Hanno.

We do not know the circumstances of many important private commissions; where we do, however, there is a pattern. The patrons, or their close friends, were well connected at the Papal court. This is best illustrated by the Papal banker, Agostino Chigi and Leo X's nephew Cardinal Giulio de' Medici, whose patronage is discussed later in this chapter. Sigismondo De Conti offers another example. Before his death in 1512 – the probable date of the painting – De Conti, the patron of the *Virgin and Child appearing to SS. John the Baptist, Francis, Jerome and Sigismondo de Conti* (the *Madonna di Foligno*), had served as segretario under Pope Paul II, Sixtus IV, Innocent VIII, Alexander VI and Julius II. According to Vasari the picture was the main altar of the church of S. Maria in Aracoeli from whence it was removed by his niece, Anna,

VIRGIN AND CHILD APPEARING
TO SS. JOHN THE BAPTIST,
FRANCIS, JEROME AND
SIGISMONDO DE CONTI
(THE MADONNA DI FOLIGNO)
Vatican Gallery, Rome

Oil on wood, 301 x 198 cm

for S. Anna in Foligno (hence its name) in 1565, while at the same time Sigismondo's burial slab in the choir of the church, immediately behind the altar, was renewed to allow his nephew Ludovico to be buried there. These changes are doubly unfortunate because Raphael alluded to the Latin name of the church in the arc of light under the Virgin's feet and because the *Madonna di Foligno* together with the tomb slab was intended to emulate in a modest way a long-enduring tradition of Papal tombs. The grandest example, that of Pope Boniface VIII (d.1303), was destroyed together with old St. Peter's but it is recorded in drawings and had influenced Perugino's 1479 fresco in the tomb of Sixtus IV in the choir chapel of St. Peter's. Boniface, who was buried under an elaborate gothic canopy on the entrance wall of St. Peter's, is shown in a reclining effigy and again above in the altar presented to the Virgin in her aureole by SS. Peter and Paul.

Raphael transformed the older scheme with brilliant colour, a simplified landscape and a figure style of greater weight and organic movement. The Virgin on whose lap the Christ Child twists is a reworking with greater breadth of Leonardo's Virgin in the centre of his unfinished *Adoration of the Magi* in the Uffizi, Florence (which had influenced the wall frescoes in the *Stanza della Segnatura*) and the simple folds of her robes are matched by those of the kneeling saints; their gestures and relative positions are subtly varied so that the apparently simple formula of two kneeling and two standing saints is achieved with no hint of monotony. The luminosity of the colour, dominated by the blue of the Virgin's robes, has an almost Venetian quality which is also found in the landscape behind the angel standing with a blank plaque. There the freedom of handling and the imaginative quality of the buildings provided the model for the visionary backgrounds of the Dosso brothers in the next decade of the century.

The *Madonna di Foligno* provided the starting point for the *Virgin and Child appear to SS. Sixtus and Barbara* (The *Sistine Madonna*) where the saints are drawn up into the heavenly vision together with the Virgin. The picture was painted as the high altar for the monastery of San Sisto in Piacenza, which housed relics of both SS. Sixtus and

Barbara which may explain why they are included in the heavenly realm, unlike the saints in the *Madonna di Foligno*. The devices which Raphael uses, the rolling clouds and the curtains drawn back to reveal the Virgin in the centre, derive – like those of the *Madonna di Foligno* – from a late Quattrocento altar in Florence, in this case the *Madonna in Glory with the Magdalen and St. Bernard* by Botticini which came to the Louvre, Paris, from S. Maria Maddalena dei Pazzi, Florence. Until 1442 the church had been dedicated to Mary Magdalen and from that date had been made over to the Cistercians one of whose most prominent saints was St. Bernard. Raphael transformed the Botticini through the calm beauty of the figures and the contrast between the kneeling saints whose poses are carefully balanced and yet still linked with the Virgin in a pyramidic grouping, which has the Virgin's head as its apex. This must also be true of the colour although this is obscured by a film of dirt which needs to be cleaned off to reveal its full splendour.

The altar is unusual in being painted on canvas rather than a panel, but this must have been to make it easier to transport it to Piacenza. It may seem surprising that Raphael should produce such an ambitious work for a comparatively unimportant monastery a long way from Rome, but Pope Julius had taken an interest in the rebuilding of the monastery while still a cardinal. And he must have retained his enthusiasm for he appears as St. Sixtus with the beard that he wore as a token of his determination to drive the French out of Italy from the beginning of 1511 until the opening of the Lateran Council in March 1512, when he shaved it off. Although the monastery in Piacenza was rebuilt slightly later than this, it seems likely that the Pope's appearance fixes the date of the picture's execution to the years 1511-12, which must also be those of his portrait by Raphael in the National Gallery, discussed below (page 137), of the *Virgin and Child with St. Jerome, Tobias and the Archangel Raphael* (the *Madonna del Pesce*) and of the *Alba Madonna* (page 132).

Little is known about the *Madonna del Pesce*, which is first mentioned in San Domenico, Naples, in 1524, but Raphael may have had an especial interest in the altar

since Tobias identifies the angel who presents him to the Virgin as the Archangel Raphael, the artist's namesake. Both the Archangel and Tobias are seen in strict profile, which links with that of one of the women on the left of the *Mass at Bolsena*

(page 80), where Pope Julius II once again appears bearded; the profile view emphasises the new simplicity of Raphael's style, which can be seen when we look back at the *Madonna del Baldacchino* (page 53). The figures are now firmly linked in the same plane, their draperies simplified and the movement which had been suggested in the earliest of the drawings for the altar is carefully avoided as Christ's gesture of blessing is suspended and frozen in time. Raphael avoids any suggestion of monotony in the composition which can be read as based upon a pyramid which has its apex in the head of the Virgin, as in earlier *sacre conversazione*. It is enlivened by the diagonal that runs from Tobias's left arm through the Virgin holding Christ and Christ's gesture of blessing to the sweeping curtain that continues the movement to the top right of the panel.

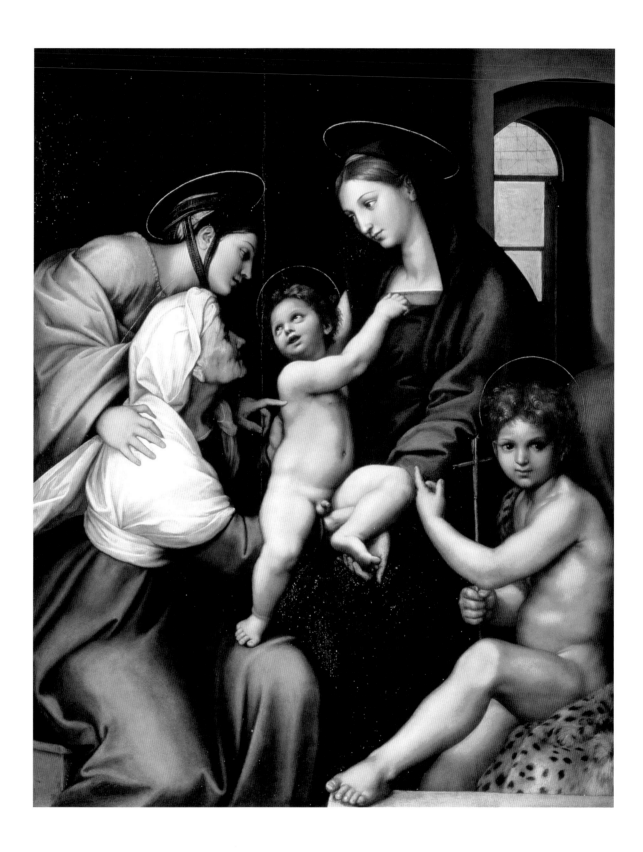

This complexity, which may well have been suggested by Leonardo's mature work, notably the London cartoon of the *Virgin and Child with SS. Ann and John the Baptist*, is continued in the *Virgin and Child with SS. Ann, Catherine and John the Baptist* (the *Madonna dell' Impannata*) in Palazzi Pitti, Florence where however, Raphael's design, which was established in two surviving drawings, has been carried out by the workshop. The date of the commission is not known, but it was painted in Rome for Bindo Altoviti – whose portrait by Raphael is discussed below (page 140) – who then sent it to Florence. The St. Ann resembles the old sibyl on the right of the S. Maria della Pace frescoes, discussed below, whose massive twisting pose reveals the influence of the second half of Michelangelo's Sistine Ceiling, unveiled on 31 October 1512. Both fresco and altar probably date from about 1513-14. As in the *Madonna del Pesce* the main emphasis is on the axis which runs from the seated St. Ann through the energetically twisting pose of Christ to the Virgin. She is emphasised by the window in the background (which itself recalls the example of Flemish fifteenth-century painting) even though she has been moved to one side so that she is no longer on the central axis of the panel. Initially her position was even more dominant for the original plan did not include St. John in the foreground whose left arm and pointing forefinger establish a secondary movement that leads to the head of St. Catherine as she concentrates upon Christ.

The compositional complexity of the *Madonna dell' Impannata* was further developed in the *Madonna of St. Francis* in the Louvre of 1518, which the workshop executed from Raphael's designs for Francis I of France together with the *St. Michael* also in the Louvre (pages 157 and 158); this underlines the simplicity of the *St. Cecilia with SS. Paul, John the Evangelist, Augustine and Mary Magdalen* in the Pinacoteca Nazionale, Bologna, where St. Cecilia stands in the centre flanked by the massive Michelangelesque St. Paul and the graceful long-necked Magdalen, inspired by the relief of the Borghese Dancers, who was the starting point for the elegant Roman mannerism so prevalent after Raphael's death in 1520.

LEFT: VIRGIN AND CHILD WITH SS. ANN, CATHERINE AND JOHN THE BAPTIST (THE MADONNA DELL' IMPANNATA)
Palazzi Pitti, Florence
Oil on wood, 158 x 125 cm

The altarpiece was commissioned for the main altar in the oratory of St. Cecilia, built at the command of Elena Duglioli dall' Olio next to the church of San Giovanni in Monte, Bologna by 1515-16. Elena Duglioli had important friends at the Papal court, notably Antonio Pucci and his uncle Lorenzo, who was created a cardinal at the end of 1513 and who must have been responsible for persuading Raphael to undertake the work himself. He may have been intrigued by what Pucci told him about Elena Duglioli: she was devoted to St. Cecilia (rather than her namesake St. Helen) because like the saint she had taken a vow of chastity with the agreement of her husband and, according to the earliest biographies, was 'raised up to celestial concerts in which she participated'.

A late tradition, which had a splendid outcome in Purcell's *Odes for St. Cecilia's Day*, linked the saint with music and so she stands isolated in the centre of the altar, while St, Paul is deep in contemplation, the Magdalen looks out at the spectator and St. John and Augustine are in discussion in the background. She no longer plays the portable organ that she holds and the instruments at her feet, including a broken viola da gamba, are neglected as she contemplates the celestial, harmony of the angelic choir which expresses the superiority of Heavenly over earthly music. The flanking saints do not share her ecstasy but they were all famous for their visions: that of St. Paul on the road to Damascus resulted in his conversion to Christianity and that of St. John on Patmos inspired the Book of Revelations; St. Augustine described his mystical visions in Milan and Rome in the Confessions and according to a late legend which was given great popularity by Jacopo del Voragine's *Golden Legend*, the Magdalen was lifted to heaven by angels during her penitence. St. Cecilia's costume is without precedent in Renaissance painting and her dalmatic and the bun of her hair, which is unlike contemporary fashions, suggests that Raphael has turned to the late Christian mosaics of S. Maria Maggiore in Rome with a sense of archaeology that finds a fuller expression in the cartoons for the tapestries.

St. Cecilia with SS. Paul,

John the Evangelist,

Augustine and Mary

Magdalen

Pinacoteca Nazionale, Bologna

Oil on wood transferred to canvas,

238 x 150 cm

PRIVATE DEVOTIONAL PICTURES

MADONNA DELLA TENDA

Alte Pinakotek, Munich

Oil on wood, 66 x 51 cm

In the period before his appointment as architect of St. Peter's in 1514, Raphael continued the series of devotional paintings with which he had made his reputation in Florence and portraiture, activities which were severely reduced later in his career. The *Madonna della Tenda* in the Alte Pinakotek, Munich, develops the classicism of his early period (the *Bridgewater Madonna* for instance) with an idealised profile of the

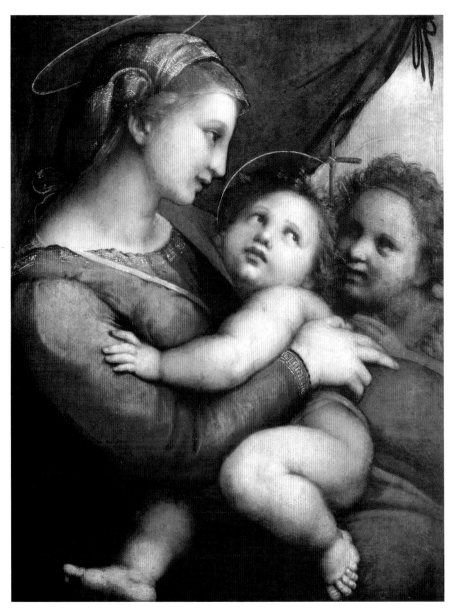

Virgin that reveals a continued debt to Michelangelo's sculpture, the *Taddei Tondo*, now in the Royal Academy, London. The figures have grown in scale to fill the whole of the picture plane and the head of the Virgin is, as so often, the focus of a pyramid which has been moved to the left of the central axis. The combination of her right arm with Christ's arm and head and the youthful Baptist create a subsidiary movement comparable to that in the altars and the profile of the Virgin is strikingly similar to that of the Archangel Raphael in the *Madonna del Pesce*. The scheme is the subject of a brilliant variation, which may well be slightly earlier in date, in the *Madonna della Sedia* in the Palazzo Pitti, Florence, where the shawl and scarf worn by the Virgin strike a note of domesticity that is echoed in the arm of her chair in the foreground. This does not distract from the tender intimacy of the painting which

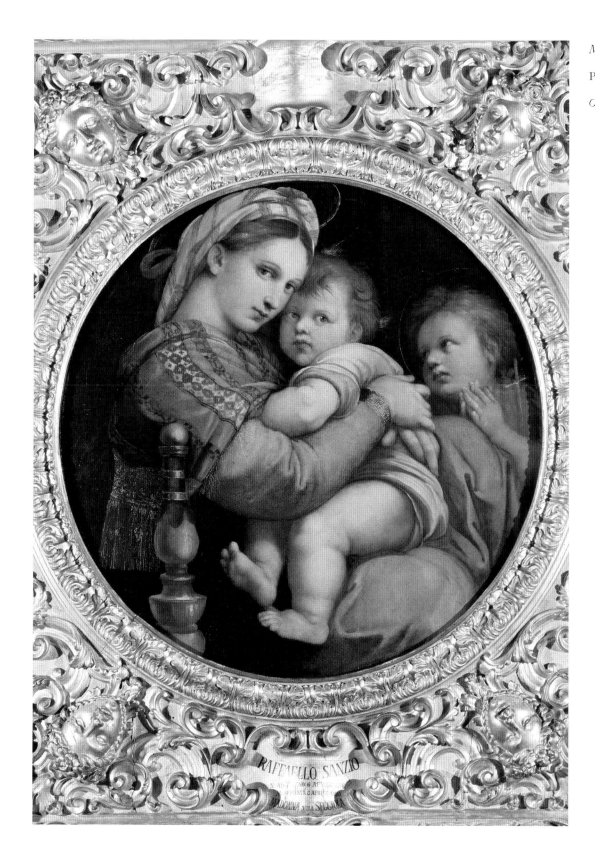

MADONNA DELLA SEDIA

Palazzo Pitti, Florence

Oil on wood, diameter 71 cm

contrasts with the monumentality of the *Alba Madonna*. The scheme of Virgin and Child with the youthful St John set in a landscape was developed from earlier devotional paintings, the *Holy Family under the Palm Tree* in Edinburgh, for example (page 51). In the *Alba Madonna* the tondo form is treated with new mastery in the graceful curve from the Virgin's head, silhouetted against the sky, through her left shoulder and slightly raised knee. Christ's half-standing, half-twisting pose appears as the culmination of Raphael's earlier paintings. The *Alba Madonna* is usually dated to 1510-11, when Raphael was working on the *Stanza della Segnatura*, with which the bold modelling of the Virgin's leg and knee shares a debt to the sibyls on the first half of the Sistine Ceiling, the Delphic, for instance.

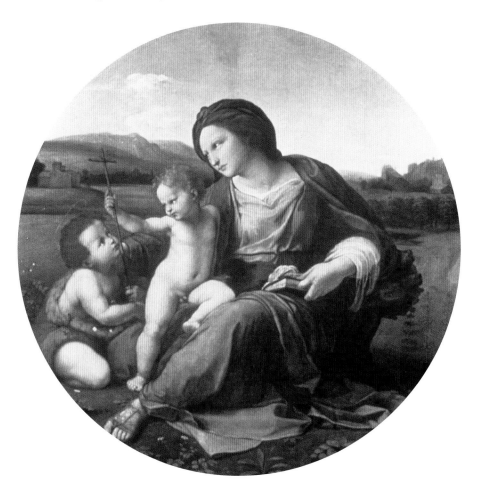

Alba Madonna

National Gallery of Art,

Washington

Oil on wood, transferred to canvas,

diameter 95 cm

PORTRAITURE

The handling of all three devotional paintings is carefully differentiated from the much more direct observation of his portraiture. This is brilliantly shown in the *Donna Velata*, which must have been painted early in the decade 1510-20. The pose of the unknown sitter is a reworking of that of Leonardo's *Mona Lisa* but a comparison with Raphael's own earlier derivations in the Doni portraits also in the Palazzo Pitti, Florence (pages 44 and 45) reveal the new mastery with which he is able to suggest the texture of the crumpled sleeve and the play of light. These interests are also found in the *Portrait of Baldassare Castiglione* in the Louvre, Paris, where the pose is comparable, but the calm even light falls from the left and the greys and blacks of his costume are thrown into vivid relief by the light background in front of which he is posed. The portrait of Castiglione was known to both Rembrandt who made a rapid sketch of it when it was sold in Amsterdam and Rubens whose copy is now in the Princes Gate collection in the Courtauld Institute, London; both Rembrandt and Rubens extended the frame at the bottom so that it no longer coincided with the sitter's left arm to form the base for the massive pyramid in which the figure is composed. Some critics have argued that Rubens and Rembrandt must have known the portrait in its original form, before being cut down, but it is more likely that their alterations reveal the baroque urge for movement that is echoed in Rubens's transformation of the sitter's calm unworried features into something much more lively and expressive.

Castiglione had been a friend of Raphael's at the Court of Urbino where he was charged to take the *St. George*, now in Washington, as a gift to Henry VII of England; in Rome, while employed as the agent of the Marquis of Mantua, he was working on the *Book of the Courtier* which established the ideal of the courtier whose good manners won the confidence of his duke. The calm authority of Raphael's picture is a perfect embodiment of the ideals that he proclaimed in the *Book of the Courtier*, just as the sense of purpose and involvement in the *Fedra Inghirami* in the Gardner Museum in Boston reflects his role as Papal Librarian first to Julius II and then to Leo X.

OVERLEAF: DONNA VELATA

Palazzo Pitti, Florence

Oil on canvas, 85 x 64 cm

PORTRAIT OF BALDASSARE CASTIGLIONE

Musée du Louvre, Paris

Oil on wood transferred to canvas, 82 x 66 cm

Inghirami, who died in 1516, is shown in his red cardinal's robes looking up from the blank piece of paper on which he is about to write with a book propped on the stand in front of him. The Boston picture is one of two versions (the other is in the Pitti Palace), of this portrait and may be the earlier original, although it is in poor condition and badly abraded. There was a well-established tradition for showing a scholar at work in his study with which Raphael would have been aware since it had been used to decorate the *studiolo* of Federigo of Montefeltro in the Ducal Palace at Urbino.

This was a series of famous men and women which had probably been painted by Justus van Ghent in the 1480s to which he may have turned as a way of helping to mask the unfortunate squint in Inghirami's right eye.

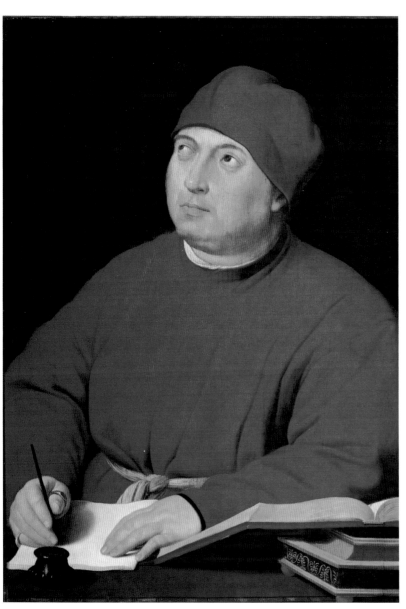

FEDRA INGHIRAMI

Isabella Stewart Gardner Museum, Boston

Oil on wood, 89 x 62 cm

Raphael's ability to transform the formulae used in the Urbino *studiolo* is brilliantly illustrated in the *Portrait of Julius II* in the National Gallery, London. Justus of Ghent had first used this seated three-quarter length pose with the sitter, Sixtus IV turned to one side. Where Sixtus was shown in full pontificals, Julius sits in a chair, whose decorative details suggest the family emblem, acorns, wearing the *mozzetta*, the official off-duty costume of senior prelates. The combination of the costume, the beard, which, as we noted in the discussion of the *The Sistine Madonna*, Julius had grown from June 1511 to March 1512 as a sign of his determination to drive the French out of Italy, and brooding mood suggest new psychological depths, which made this the precedent for the Papal portrait.

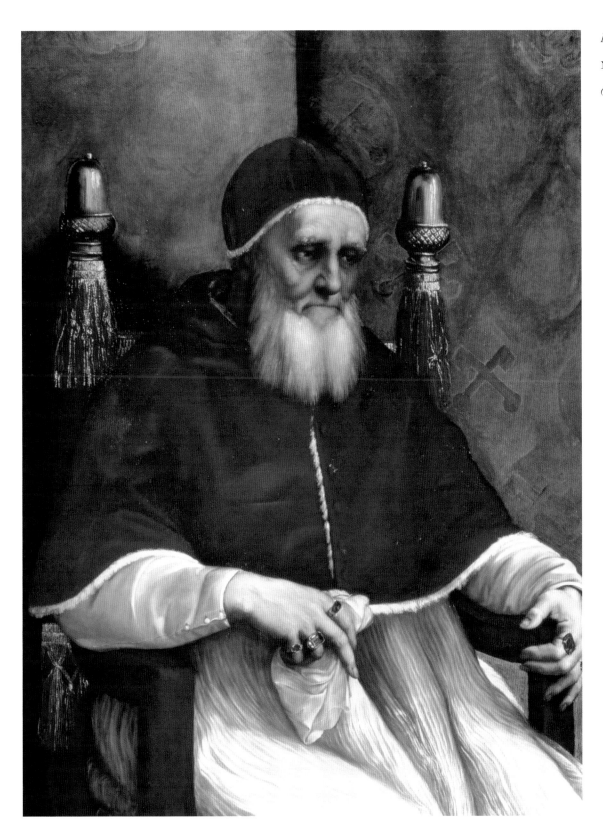

PORTRAIT OF JULIUS II

National Gallery, London

Oil on wood, 108 x 80 cm

Raphael returned to the northern tradition for another masterful portrait, *Pope Leo X with Cardinals Giulio de' Medici and Luigi de' Rossi* in the Uffizi, Florence, which must have been painted between 1517, the date at which Leo's nephew Luigi de Rossi was created a cardinal, and 1519 that of his premature death. In the 1440s the great French painter Jean Foucquet had painted a portrait of *Pope Eugene IV with two attendants* which, although it has not survived, was later admired in the sacristy of S. Maria sopra Minerva, Rome; it must have formed part of the inspiration for this type of group portraiture which was taken up by Raphael's great rival, Sebastiano del Piombo, in his *Cardinal Bandinello Sauli and Suite* in the National Gallery, Washington, which is dated 1516. Raphael has responded to Sebastiano's challenge in the Flemish-inspired realism of the illuminated manuscript which the Pope has been studying. He has also given his design greater monumentality and unity through the diagonal which rises up through the edge of the table and the Pope's left arm to that of Luigi de' Rossi standing behind his chair. This gives the portrait a formal unity but Raphael has deliberately played down the informal psychological unity that he felt appropriate for the double portrait in the Louvre where he appears with a gesturing man who is generally identified as his fencing master (page 173). The vague but striking setting is suitably magnificent while the massive figure of the Pope just turns his eyes to acknowledge the presence of his cousin Giulio de' Medici.

The *Portrait of Bindo Altoviti* in the National Gallery, Washington, which may well have been painted in the same period, underlines the formality of the portrait of Pope Leo X. Altoviti has been posed with his right shoulder towards the spectator to whom he turns and looks. The delicacy of the modelling combined with the subtlety of the light falling from the left which are developed from the *Donna Velata* belie the attribution to Giulio Romano made by some modern critics and show that Altoviti had greater luck with this, his second commission from Raphael, than with the *Madonna dell' Impannata*. Altoviti was a banker who, like the greatest of the profession in Rome, Agostino Chigi, was a patron of the arts. Raphael may well have chosen the pose as a compliment to this interest for it derives from a formula invented by Giorgione which had been popularised in Rome by Sebastiano del Piombo.

RIGHT: POPE LEO X WITH CARDINALS GIULIO DE' MEDICI AND LUIGI DE' ROSSI
Gallerie degli Uffizi, Florence
Oil on wood, 154 x 119 cm

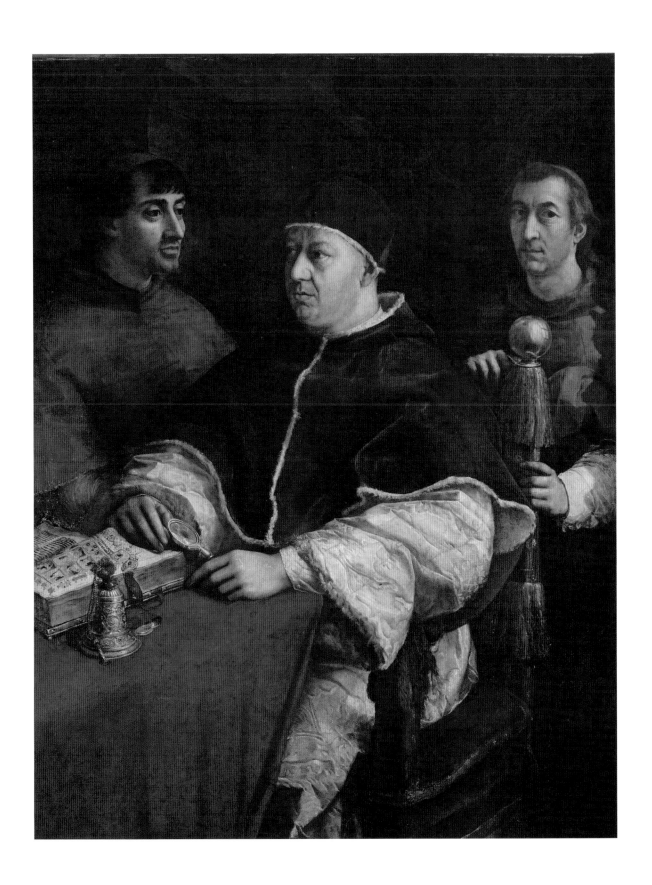

Portrait of Bindo Altoviti

National Gallery, Washington

Oil on wood, 60 x 44 cm

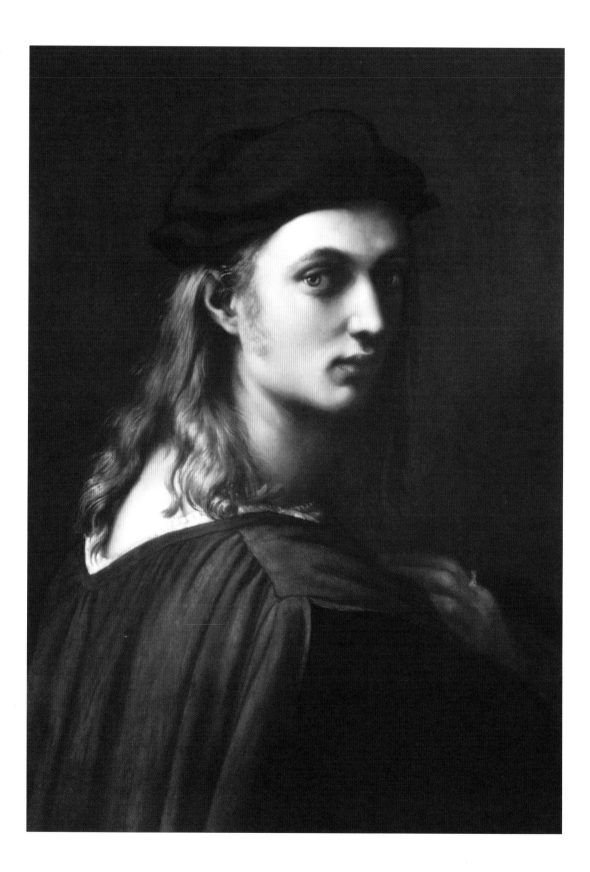

THE PAPAL BANKER, AGOSTINO CHIGI, *GALATEA*

The great Papal banker, Agostino Chigi, used wealth to secure his social position, not simply through lavish expenditure on food but also through patronage of humanists and painters, including Peruzzi and Raphael, the Papal artist. We get a vivid sense of the resulting one-upmanship in a poem by Filippo Beroaldo 'while you lead us around your villa's dining rooms, and stroll through all the gardens, my dear Chigi, the time goes by and my guts are shuddering from starvation. Don't dare think that my stomach feeds on painting, noble though that may be; come on, get on with it. Leave admiration until we're drunk.' Others took the word-play Agostino-Augustus to suggest a parallel, which had to handled tactfully in the Rome of Julius and Leo.

Chigi suffered in the eyes of contemporaries from his merchant background, illustrated by his unsuitability as a match for the Gonzagas, when he opened marriage negotiations after the death of his first wife in 1512. In that year he commissioned another humanist, Blosius Palladio, to describe his Suburban villa, now known as the Farnesina, published in 1512, although its decoration was incomplete. The villa, designed by his fellow Sienese artist and architect, Baldassare Peruzzi, was sited on the Lungara, cut along the Tiber to connect St Peter's with Trastevere. The Farnesina's two storeyed 'E' shape, omitting the central, is traditional but has been brought up-to-date through the decoration of the exterior with a rich cornice, applied pilasters and with frescoed grisailles.

The frescoes of the ground-floor loggia overlooking the Tiber were planned for the spectator entering with their back to the river. The central vault is dominated by Chigi's coat-of-arms (although these have subsequently been changed) and by a cycle devoted to the heavenly constellations at the moment – probably, since casting ancient horoscopes is fraught with difficulties – of Chigi's birth. Under the heavens Sebastiano del Piombo, who Chigi had recruited on a visit to Venice in 1512, painted the lunettes with frescoes devoted to the air. Two elements were left, earth (*Polyphemus*) by Sebastiano gazing on his beloved *Galatea* (water).

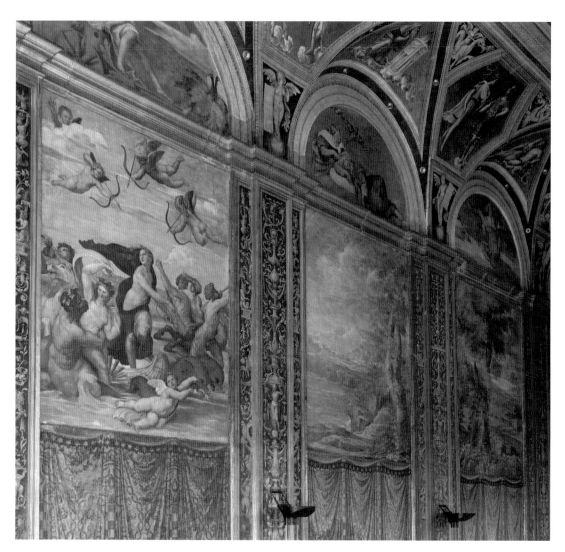

She is accompanied by marine hippocamps and nereids as her sea-shell is drawn away from Polyphemus by twin dolphins. This image of Galatea was inspired by Politian's *Stanze per la giostra* from the end of the fifteenth century, a version of the *Imagines* of Philostratus. To these literary sources Raphael added another, the detail of the leading dolphin eating an octopus, can only be explained in the light of the *Halieutica of Oppian* (3rd century A.D.) where the dolphin is described as the 'lord of the sea' in contrast with the octopus which is described as low and murderous. According to legend Galatea spurned Polyphemus for Acis, who Polyphemus killed out of jealousy. The victory of the dolphin over the murderous octopus gives the legend an emblematic 'happy ending'.

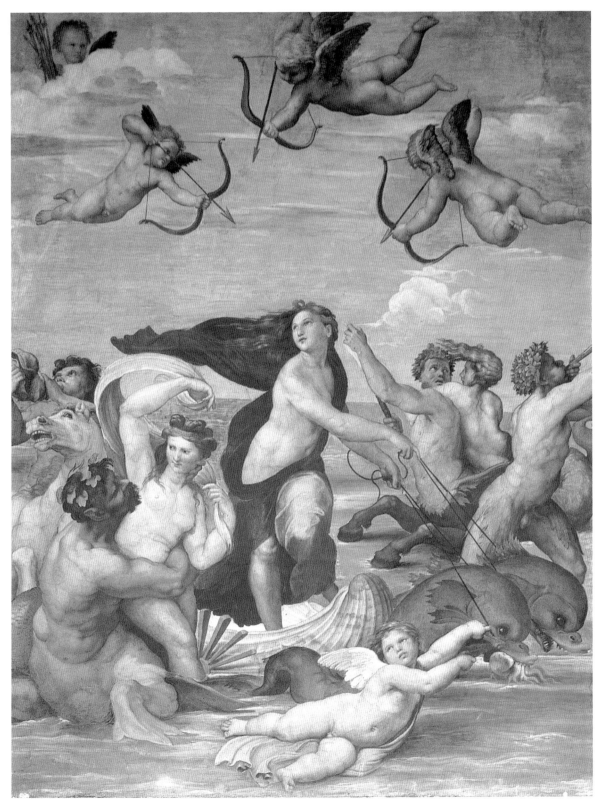

GALATEA

Farnesina, Rome

Fresco

The power of love is further underlined by the inclusion of the winged putti aiming their arrows at Galatea, while Cupid is drawn along by the foremost dolphin. These are the attributes not of the nereid Galatea but of Venus, the goddess of love. Because of this, and because Raphael's fresco was planned with no reference to the *Polyphemus*, it may well have been completed before the Sebastiano and have been mistaken for a fresco of Venus in Palladio's description of the villa.

The range of visual sources on which Raphael drew for the *Galatea* matches that of the texts. Galatea in the centre, riding in triumph in a sea-shell accompanied by nereids, amoretti and tritons, was suggested by marine sarcophagi, like that of the triumph of Neptune then on the Aracoeli. This also suggested the strange form of the tritons, male down to the waist, thence with great twisting tails and the nereid seen from behind, holding her mount with an arm over his shoulder. Raphael transcended his source by extending the composition in depth, by breaking its symmetry, and by using monumental sources. Galatea's twisting pose was inspired by that of Leonardo's *Leda*, while the muscular forms of the tritons resemble the ignudi of the Sistine Ceiling and the Torso Belvedere.

Chigi was not content with the Villa Farnesina as designed by Peruzzi and shortly after the completion of the main block acquired more land. In 1512-13 Raphael was commissioned to design the long two-storeyed block of stables for this new strip along the Via della Lungara. Although ruined the stables can be reconstructed from a few remains and drawings. The facade facing onto the road was articulated by pairs of pilasters, which supported a cornice and framed square-headed windows, with Doric on the ground-floor and Corinthian above. The articulation of the facade and use of the twin pilasters is richer than in the villa, and resembles the great niche in the Belvedere, although both the detailing of the bases and the reference to triumphal arches in the attic reveal the creative independence which was to blossom in further commissions for Chigi.

S. Maria del Popolo and Santa Maria della Pace

Agostino Chigi used Raphael again in the Farnesina, to which we will return later, and in two chapels in S. Maria della Pace and S. Maria del Popolo, a site which testifies to Julius II's regard for the banker. Julius had commissioned Bramante, Andrea Sansovino and Pintorricchio to extend and decorate the choir of the church, rebuilt under Sixtus IV. Chigi's chapel on the right nave is articulated by richly

CHIGI CHAPEL

S.M. del Popolo, Rome

fluted, coupled Corinthian pilasters, which support pendentives and a cupola above a drum. They are decorated with swags and niches and frame four great openings, two of which are filled with the tombs of Agostino Chigi and his brother Sigismondo. The architectural system and articulation of the walls is an elegant reduction of the crossing of St. Peter's, as planned by Bramante. Raphael's is anything but a slavish copy, a point that is brought out in the richness of surface and decoration. The detailing of the Corinthian pilasters was based on that of the entrance portico to the Pantheon, while the four great curved vaults under the cornice resembles those in its interior. The dome, divided into eight fields with a central oculus, is also reminiscent of that of the Pantheon. It is decorated with the seven planetary gods together with their zodiacal signs and the sphere

of the fixed stars. These are placed under the protection of angels and of the foreshortened God the Father, clearly inspired by Michelangelo's Sistine Ceiling, greeting Agostino and Sigismondo Chigi together with the spectator entering the chapel. The mosaic, designed by Raphael and executed by the Venetian mosaicist Luigi da Pace by 1516, was intended to crown *Assumption of the Virgin*, planned for the altar but replaced by Sebastiano del Piombo's *Birth of the Virgin* after the deaths of both Agostino Chigi and Raphael.

By contrast with the mosaics, where Raphael drew on Renaissance sources, the architecture and funerary sculpture reveal an elegant reworking of classical models. The pyramidal shape of the twin tombs follows a long-established tradition, inspired by the mistaken view that the surviving pyramids in Rome had been used for the burial of Julius Caesar and Remus. This may also have played its part in the choice of porphyry for the cladding of both tombs, long associated with the emperors and reflecting the flattering terms of the poetry dedicated to Agostino Chigi, where he was equated with Augustus. The colouristic splendour of the tombs would have been enhanced by bronze reliefs cast by Lorenzetto from designs by Raphael. The *Christ with the Woman of Samaria*, the only one to have survived but on the altar rather than on one of the tombs, is one of the first works to reveal his enthusiasm for the relief of the Borghese Dancers. Lorenzetto was responsible for two of the marble sculptures in the niches – the remainder were completed over a century later by Bernini – the *Jonah* and the *Elijah*. Both were adapted from classical sources, the *Jonah* from a statue of Antinous and the *Elijah* from the Apollo then in the della Valle collection. The 'magnificence' of Chigi's funerary chapel both continued a quattrocento tradition, represented by the chapel of the muses in the Ducal palace at Urbino, and fulfilled Raphael's views on the rich ornaments of classical ornament, as set out in his letter to Leo X of 1519

The ceiling, with its combination of constellations and angels, symbolised the region to which the souls of Chigi, his brother and the Virgin return after death and the

triumph over death plays a considerable part in the badly-damaged frescoes in S. Maria della Pace. These are divided to fit with the chapel, the first on the right of the nave. The sibyl on the left, for instance holds a Greek scroll which when translated means 'the Resurrection of the Dead', a theme that is repeated in all the other inscriptions; the seated prophet above this sibyl (wrongly identified by the inscription underneath as Habbakuk) holds a passage from Hosea 6, 2: 'After two days he will revive us; in the third day he will raise us up.' The text has a clear relevance to the Resurrection and Raphael made a number of drawings for an altar of this subject which was intended for this chapel. It was subsequently commissioned from Sebastiano del Piombo who did not carry it out even though Michelangelo helped with a group of drawings. Raphael designed sculpture for both chapels which must have been intended to match the richness of classical ornament which he so admired; a copy after a preliminary drawing shows roundels flanking the altar and the bronzes which Raphael designed and which were cast by Lorenzetto are now in the Abbey of Chiaravalle. The scale of the figures at this early stage of the design is much slighter than in the frescoes, and the change underlines the impact of the unveiling of the second half of the Sistine Ceiling in October 1512.

Chigi Chapel

S.M. del Popolo, Rome

Ceiling mosaics

Sala di Psiche, Villa Farnesina

We see a very different side of Raphael in the *Psyche Loggia* in the Farnesina, completed at the beginning of 1518. The legend of Cupid and Psyche had been chosen for this loggia because of the classical statue of Psyche which Agostino Chigi displayed in the garden, but the choice of scenes with a tapestry of the gods' feast hanging over those guests lucky enough to enjoy Chigi's hospitality reveals Raphael's wit and decorum.

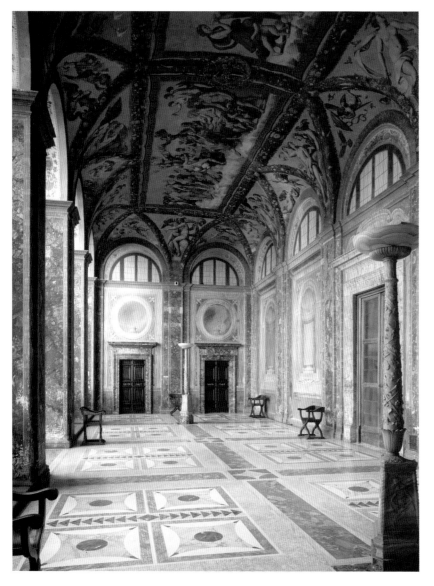

The centre of the room is marked by Agostino Chigi's coat-of-arms. This is the focus of the trellis painted with incomparable richness of fruit and flowers supporting two illusionistic tapestries. Some of Psyche's tasks are enacted in the main spandrels, while in the smaller above the later illusionistic windows putti disport themselves with the attributes of the gods and goddesses. The scenes were taken from the legend of Cupid and Psyche in the *Golden Ass* of Apuleius. This erotic classical text was well known in the Renaissance, which had placed the story of Psyche's sisters urging her to discover the identity of her lover on the front of marriage chests, as a warning against curiosity. Raphael selected her later trials and in the two mock-tapestries the *Assembly of the Gods* and their *Feast*, which celebrated the marriage, to which all in the loggia are invited by Mercury in the spandrel of one of the shorter walls.

While the selection has a compelling logic much has been left out and although unveiled in 1518 it is clear that Raphael planned a more complete scheme. Cupid draws the attention of the three Graces to an action lower down on one of the walls which may have been intended for a tapestry. As with the *Galatea* Raphael has interwoven a second text to underline the message of the main frescoes. The putti set on the underside with a different viewpoint illustrate an epigram by Philippus: 'Look how the Loves, having plundered Olympus, deck themselves in the arms of the immortals, exulting in their spoils'. They bear the bow of Phoebus, the thunderbolt of Zeus, the shield and helmet of Ares, the club of Hercules, the three-pronged spear of the sea-god, the thyrse of Bacchus, Hermes's winged sandals, and Artemis's torches. Mortals need not grieve that they must yield to the arrows of the Loves, if the gods have given them their arms wherewith to busk themselves.' This hedonistic plea may have been intended as an excuse for Chigi who was 'advised' by the Pope in 1519 to marry the mistress with whom he had been living since 1511.

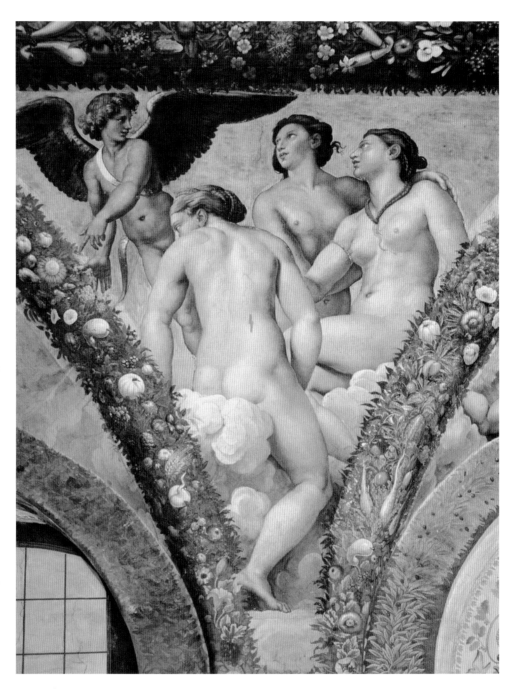

CUPID AND THE THREE GRACES

Psyche Loggia in the Farnesina

Fresco

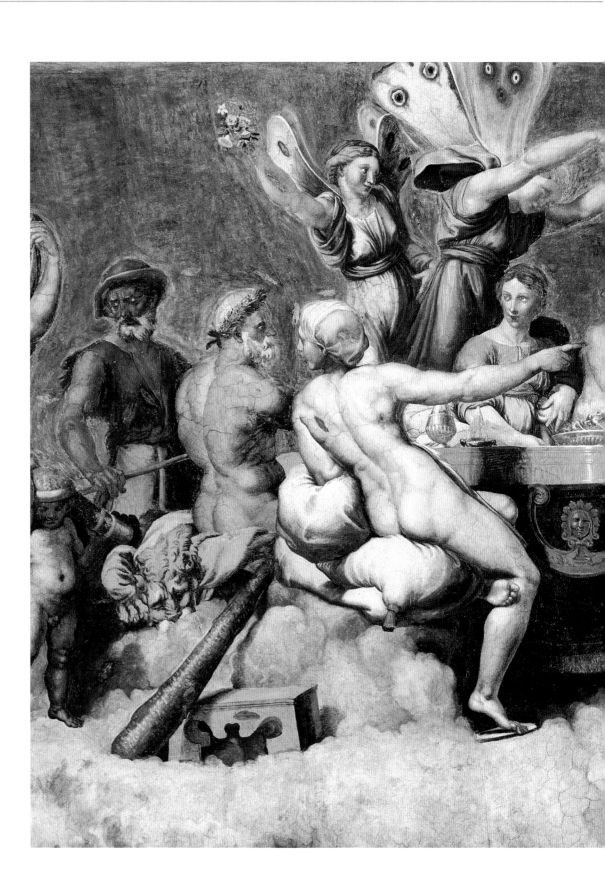

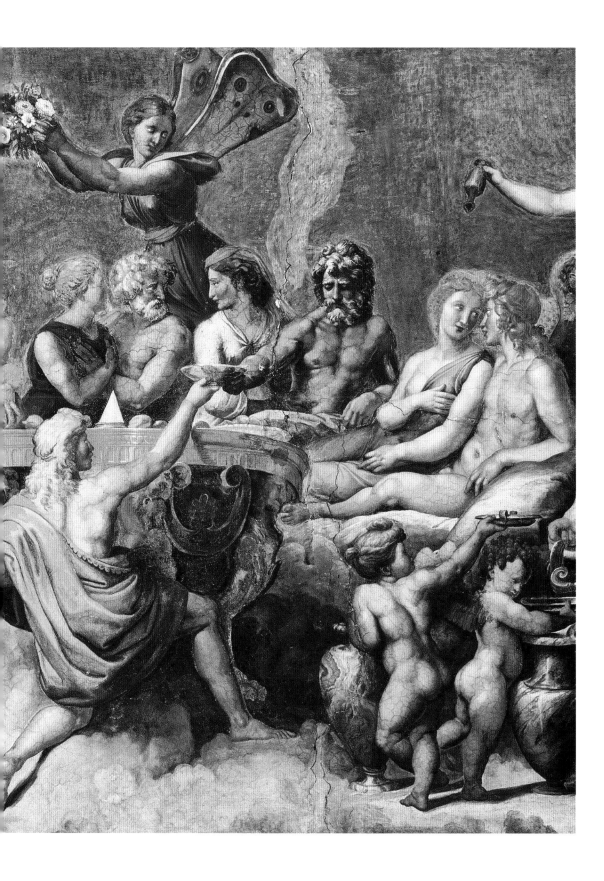

COUNCIL OF THE GODS

Psyche Loggia in the Farnesina

Fresco

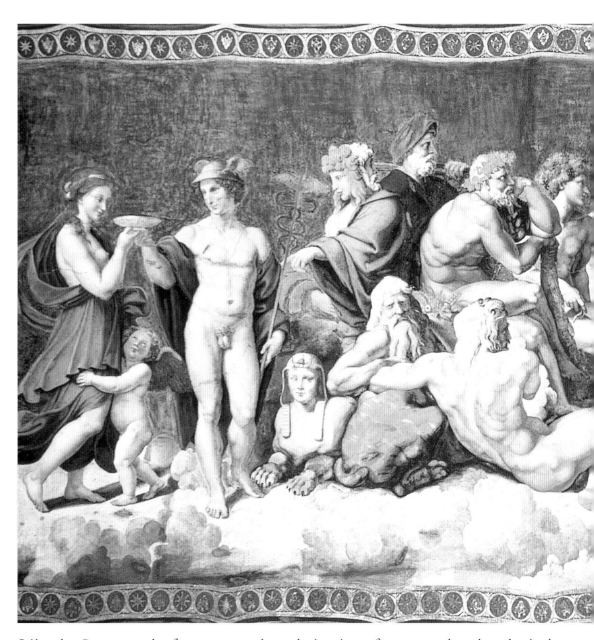

Like the *Parnassus* the frescoes are the culmination of a renewed archaeological interest in the gods and goddesses of antiquity which once again combined their appearance with their deeds as described in classical texts, here Apuleius. The fashion for northern secular decoration and tapestries continued in Italy well into the middle of the fifteenth century, when patrons began to demand decorations based on classical texts rather than French-inspired Arthurian legends. The first generation of artists to fulfil these commissions, Botticelli in

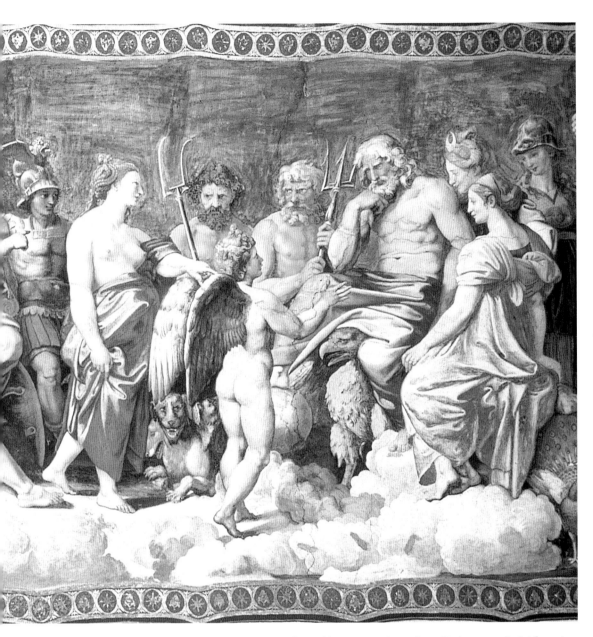

Florence and Francesca Cossa and colleagues in the Palazzo Schifanoia, Ferrara, were only able in part to respond to this new interest. The notable exceptions were Mantegna in his *Triumph of Caesar*, and to a lesser extent Piero della Francesca in some figures in his frescoes at Arezzo, whose archaeological attitude and interest in large-scale classical statuary was later developed by Leonardo both in the *Last Supper* and in the *Leda*, whose influence on Raphael we have already noted.

The individual figures and the compositions of the *Council* and the *Wedding Feast* transcribe classical models with wit and a true Renaissance sense of decorum. Mercury flies in to call us to the Feast, born aloft by the wings on his feet, which are echoed in those of his helmet, holding a trumpet in his capacity as the gods' messenger. Mercury's muscular appearance is contrasted with the feminine *Three Graces* where Raphael continues the contrast of front and back views of his own earlier version of this subject, with the new mastery of large-scale figures that he had developed in Rome. In the *Council of Gods* Venus brings Cupid before Jupiter on the right whose judgement is followed with intense interest by the seated Hercules, next to Janus with the Sphinx below, but ignored by Mercury distracted by the offer of a glass of nectar. In the *Wedding Feast*, Apollo seen from behind on the left plays his lyre to provide the music to which the Horae dance as they scatter roses over the guests reclining, in true Roman fashion, at the table with the newly-wed Cupid and Psyche on the right with the Graces in attendance. The illusion that both compositions are tapestries avoids the need for foreshortening but the rolling clouds on which the figures are set introduces a sense of realism that was to be extremely popular in the seventeenth century

After this description of one of the most light-hearted and successful of all Renaissance creations it comes as a surprise to find it heavily criticised at its unveiling; in a letter dated 1 January 1518, Leonardo Sellaio, one of Michelangelo's friends, writes to the master in Florence: 'Sebastiano del Piombo has nearly finished [this is a reference to the *Raising of Lazarus*], and succeeds in such a manner that those who understand place him by far above Raphael. Agostino Chigi's vault has been uncovered; its a disgrace to a great master; worse than the last stanza of the Palace [the *Stanza dell' Incendio*] so that Sebastiano has nothing to fear.'

The Papal Family

Lorenzo de' Medici

Leo X's relationship with his nephew, Lorenzo de' Medici (1492-1519), illustrates both his wider political agenda and concern to establish a family dynasty. This latter was emphasised in the ceremony of September 1513 in which Lorenzo was invested with Roman citizenship together with another of the Pope's nephews, Giuliano de' Medici (1478-1516), the Duke of Nemours. At the climax of the two days of proceedings, which were celebrated on the Capitoline, the *Deus Capitolinus* (Capitoline god) hailed Giuliano and Leo X, through whom 'Rome will reassume the curule chairs; Italians freed from care, will return to their standards; the ancient Campus Martius will renew its rights of suffrage. Thus as true physicians [Medici] your name will mount to the stars and the fame of your race will be celebrated eternally.'

The ceremony was accompanied by the commission for a colossal marble statue of Leo X, set up on the Capitoline on 21 April 1521, and an oration prepared by Blosio Palladio, a leading humanist, the length of which meant that it was never delivered. The theme was that decline had been offset by the establishment in Rome of the Christian church and that this new Christian empire surpassed its predecessor, through a series of heroic popes, culminating in Leo X, whose actions were those of a new emperor, Augustus bringing peace to the empire after the wars of his predecessor, Julius.

It came on very different terms from its classical precedents. Italy was once more in turmoil as large foreign armies, during Leo's pontificate the French under Francis I, sought to establish command over areas of Italy. Leo's successors, as noted in our account of the programme for the *Sala di Costantino*, were faced both with the French and the newly invigorated Holy Roman Empire, under the Emperor Charles V. Where Julius led his armies in the long-term aim of freeing Milan from the control of the French, Leo had to turn to diplomacy after September 1515 as Milan and

Lombardy were conquered by Francis I, following his great triumph at the battle of Marignano. We have discussed one aspect of Leo's negotiations with the French in the account of the *Stanza dell'Incendio*, another is seen in the *Large Holy Family* and *St Michael Trampling the Demon*. Both are inscribed with Raphael's name and the date, 1518 and were commissioned by Leo X to be presented to Francis I by Lorenzo de' Medici, then papal ambassador at the French court. Although the inscriptions added the assurance that both were by the papal artist, by 1518 the demands on Raphael's time meant that even these major diplomatic gifts were executed by the workshop, most notably Giulio Romano.

St Michael Trampling the Demon was chosen because Francis I was grand-master of the chivalric royal order of St Michael, and the archangel was considered France's patron saint. St Michael stands on the demon, poised on his right leg, with the left thrown out behind establishing a diagonal which runs down the right arm. The elegance of the pose is matched in the head, developed from the Magdalen in the St. Cecilia with SS. Paul, John the Evangelist, Augustine and Mary Magdalen. By contrast with the earlier St Michael, also in the Louvre (page 21) but not painted for the French court, the saint wears a classical cuirass, and the winged demon is human, a change intended to underline Francis' support of the church and commitment to crusade against the continued threat of the Turks.

RIGHT: ST MICHAEL
TRAMPLING THE DEMON
Musée du Louvre, Paris
Oil on wood, transferrred to canvas,
268 x 160 cm

The mood of the *Large Holy Family* (*The Virgin and Child with Sts Joseph, Elizabeth and St John with angels*) is very different, as were the circumstances it celebrated. The 1513 ceremony to invest Lorenzo and Giuliano de' Medici with Roman citizenship is one indication of Leo's dynastic policy. The Papacy gave him the opportunity to achieve control over Florence, which was to be cemented by marriage into the major European

ruling families. Over a century later, for example, the Medici were in serious negotiations with the court of St James to persuade the future Charles I to take a Medici bride, following a policy established with Lorenzo's marriage to Madeleine de la Tour d'Auvergne, Francis I's niece. This may have prompted Raphael to adapt the motif of the hours sprinkling flowers over the newly married Cupid and Psyche in the *Marriage Feast* on the ceiling of the *Sala di Psiche* in the Farnesina for the angel holding the garland over the Virgin's head. This adds to the complexity of a design developed from the *Madonna dell' Impannata* and enhanced with a virtuoso swirling marble floor, and with the broad, classically inspired, handling of the Virgin's robe. This was characteristic of Raphael's late work and was very suitable as a parallel to the Pope's other gifts to Francis, which included a life-size model of the *Laocoon*, the centrepiece of the papal collection in the Belvedere.

LARGE HOLY FAMILY
(THE VIRGIN AND CHILD
WITH STS. JOSEPH, ELIZABETH
AND ST. JOHN WITH ANGELS)
Musée du Louvre, Paris
Oil on wood, transferrred to canvas,
207 x 140 cm

Cardinal Giulio de' Medici

The *Transfiguration*

The most influential of the private patrons was Cardinal Giulio de' Medici, the future Pope Clement VII. He was an illegitimate cousin of Pope Leo X, who appointed him a cardinal and vice-chancellor of the church. Clement was Leo's principal aide and played a significant role in his Florentine commissions, including the competition for the facade of San Lorenzo, abandoned by 1519 in favour of the new sacristy, and the decoration of the *salone* of Poggio ai Caiano. The Pope's active involvement in these schemes mean that Cardinal Giulio was not entrusted with the major share in the administration and patronage developed by later counter-reformation cardinal-nephews. However, he remained a substantial patron of classical sculpture, painting and architecture in his own right. He purchased some of Giovanni Ciampolini's collection for the garden of Villa Madama after Ciampolini's death in 1518. In painting he fostered Leo's ideal of artistic competition through the simultaneous commission of the *Raising of Lazarus* from Sebastiano del Piombo and of the *Transfiguration* from Raphael, discussed further below.

Sellaio's letter, quoted on page 154, provides the context within which to discuss Raphael's last great altarpiece, the *Transfiguration* which had been commissioned by Cardinal Giulio de' Medici for his cathedral in Narbonne together with Sebastiano del Piombo's *Raising of Lazarus*, now in the National Gallery, London. Sebastiano had finished his altar, which is comparable in size, by May 1519 and was confident that he had beaten Raphael. Raphael's altar was completed after his death by Giulio Romano, who was responsible for the execution (not the design) of the woman kneeling just to right of centre and of the group around the possessed boy to whom she points. In spite of this the *Transfiguration*, rather than the Sebastiano, was retained in Rome where in 1523 it was set on the main altar of S. Pietro in Montorio. This suggests that Sebastiano's hopes were dashed and that Raphael was

*T*RANSFIGURATION

Vatican Museum

Oil on wood, 405 x 278 cm

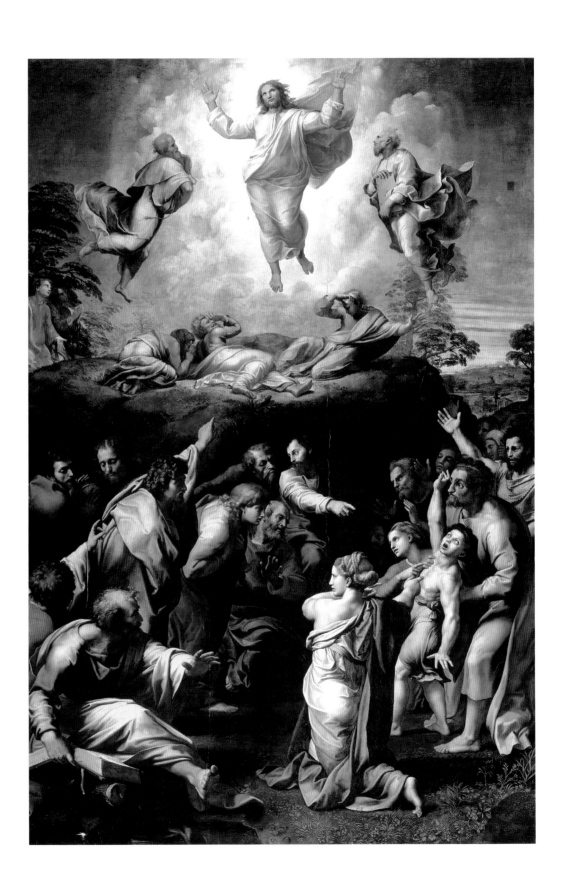

the victor in this comparison of hands. This must have formed a part of the patron's original intention, as the outcome of the Renaissance interest in individuality with the consequent rise in the status of the artist.

The reasons for Raphael's victory are complex like the *Transfiguration* itself; the altar fuses the moment of the Transfiguration (Mark 9, 2-13 and Matthew 17, 2-13) where Christ 'was transfigured before them; and his face did shine as the sun, and his raiment was white as the light. And, behold, there appeared unto them Moses and Elias talking with him', with the next episode in both gospels where, when Christ comes down from Mount Tabor, he is met by a man with a mad son whom he had taken to those of Christ's disciples not witnessing his Transfiguration who had failed to heal him. This combination, which is without precedent, was not a part of Raphael's initial plan for a Transfiguration without the scene of the healing of the sick boy. The change was in response to the stately composition of the *Raising of Lazarus*, based on the interlocking of two pyramids.

By changing the *Transfiguration* Raphael achieved a tauter, more highly-charged drama where the apostles in the foreground face the father and the sick boy and through their gestures focus on the radiant Christ. Mt Tabor is set behind this group and although the change in scale to Peter, James and John hiding their eyes from the light suggests considerable depth this is denied by the links between Christ and the foreground group. The drama is expressed in every detail of the panel, the foreground apostle, for instance, leaning forward, his hand outstretched in response to the gesture of the woman pointing to the boy. As as with many of the other heads his was studied after the cartoon-stage in an auxiliary cartoon pricked for transfer and drawn to the same scale as the panel, a procedure that Raphael had used earlier, notably for the *Coronation of the Virgin* (page 16), but never so extensively.

The auxiliary cartoons with their superb delineation of character and control of light and shade recall the masterful drawings with which Leonardo had prepared the soldiers in the central section of the *Battle of Anghiari*, perhaps an intentional reminiscence as a response to the knowledge that Michelangelo had provided Sebastiano with drawings for the *Raising of Lazarus*. Raphael's composition and some of the heads recall other works by Leonardo, most notably the unfinished underpainting of the *Adoration of the Magi* but it would be a mistake to overemphasise this debt. Raphael's colours have a richness and range very different from Leonardo's paintings and which was only recovered as a result of a 1970s cleaning. The panel had started to darken by the 1540s when Vasari was collecting material for his *Lives*. He described it as having suffered because of Raphael's use of printers' black but as still 'piuttosto tinta che altrimente' (predominantly coloured); the process of darkening had continued so that before the cleaning (the state shown in most of the older photographs and reproductions), it appeared to be Leonardesque in its range of light and shade. Rather, Raphael fused the Leonardesque system with a much more Venetian sense of colour to counter the rich but muted Venetian colour and bold Michelangelesque forms of the *Raising of Lazarus*.

THE VILLA MADAMA

Giulio de' Medici's most significant commission was for the Villa Madama, on the Monte Mario overlooking the Ponte Molle and St. Peter's. The commission shows that the cardinal did not share share the scepticism of Raphael's ability as an architect expressed by Alfonso d'Este's Roman agent. After failing to persuade Raphael to produce paintings for Alfonso's *studiolo* his agent reported back to Ferrara somewhat sourly that 'men of this calibre [Raphael] feel full of melancholy. And he feels it especially since he has worked at architecture and is doing a Bramante.'

RIGHT: INTERIOR OF THE VILLA MADAMA, ROME

The elegant garden *loggia* of Villa Madama, together with half of the round courtyard, are still used for receptions by the Italian Foreign Ministry. This, though, represents only a small part of Raphael's original plan for the site, as this is known through drawings, albeit from the Sangallo workshop, and from the description of the villa which he prepared in 1519. Patron and artist intended a building at least twice as long as the present villa, with a great suite of stables at the lowest level, set in front of a hippodrome. The mass of the villa rose above this, with elegant Doric portals, defensive towers at the corners and a round courtyard at its centre. This was framed by *loggias* which led out on one axis to the main entrances, and on the other to the gardens, and to a series of ramps with a fountain and circular theatre further up the mountain.

The failure to complete such an ambitious scheme can in part be explained as the result of external pressures, the Cardinal's involvement in the restitution of the Medici in Florence, his subsequent election as Pope and finally the Sack of Rome in 1527. The fate of Villa Madama, however, also fits with other projects of the period, where artist and patron were fired with the aim of emulating the scale of Roman Imperial buildings, without the necessary resources. These schemes had been inspired by both the visual and the literary records of antiquity, and both traditions played an important role in the Villa Madama. The idea of planning houses around a circular courtyard had been revived by Francesco di Giorgio, as a result of his knowledge of the villa of Marcus Terrentius Varro. Raphael exploited this scheme with its emphasis upon the central axis but the elements around his courtyard balance each other only loosely. His use of asymmetry in the context of architectural planning resembles that of his later monumental frescoes. The rooms around the central courtyard are similarly varied, in imitation of those at Hadrian's villa at Tivoli, which he had visited with Bembo and Navagero in 1516. It inspired both the general scheme and one striking detail, the deep niches of the fish-pond which support the upper garden.

RIGHT: CEILING DETAIL OF

THE VILLA MADAMA, ROME

In his description of the villa Raphael attempted to match his experience of Hadrian's villa with the descriptions of Pliny the Younger and Vitruvius. He began with the twin entrances; first from the Ponte Molle, leading to the main body of the building, and then from the Vatican, which leads to the principal entrance on the short south-west side. After the entrance, defended with twin towers, comes the courtyard at whose head 'is a vestibule, whose form and function is in the antique style, with six round Ionic columns and the piers which this type requires. From this one passes to the atrium, made in the Greek style and like the kind of thing Tuscans called an 'androne'', This then leads on to the circular courtyard but Raphael continued with the rooms around the southern side of the building. These included the kitchen range, a garden with orange trees and a fountain and one of the corner – towers, in which 'is placed a very beautiful dyeta as the ancients called it. The form of which is round and six canne in diameter. It can be reached by a passage which provides shelter for the gardens. The dyeta is circular and has glass windows all around it, which the sun will successively fall on and shine through on its journey from sunrise to sunset. The place will thus be most charming, not only because of the continuous sunshine but also because of the view of Rome and of the countryside...It will be a most pleasant place in winter for civilised discussions – the customary function of the dyeta.'

Raphael identifies two further dyetae to be used in summer – the garden *loggia*, the one major section which was completed, and the fountain in front of the theatre. That in the *loggia* 'is quite delightful both because it will never receive the sun and because the water and greenery make it beautiful... The *loggia* gives on to the xystus (to use the ancient term), a place full of trees planted in order... The xystus has some parapets which look down below where a fish-pond can be seen. Around it are some steps which go right down and may be used for sitting or stretching out on.' Raphael's scheme included another use for water, inspired by classical thermae. The entrance from the Ponte Molle led from the stables and the hippodrome to a Doric portal, in the form of a tower 'this leads to what the ancients called a cryptoporticus. We would call it an underground portico, although there are a number of different kinds of cryptoporticus. But this is one which acts as a vestibule. Opposite the portal is a

fountain in a niche...From the left-hand side of this cryptoporticus one can go south to the baths. These have been arranged so that there are two changing-rooms and then a warm open space for oiling oneself after bathing or being in the hot-room.'

The new Roman senator had the best of both worlds: the high walls and corner towers of the massive facade resembled the ducal palace at Urbino, the source for the relationship of gardens at different levels. Not surprisingly these debts, and that to Francesco di Giorgio, are outweighed by that to Bramante. Some ten years earlier he had designed, probably for Cardinal Pompeo Colonna, a now charmingly decayed nymphaeum near the family stronghold of Genazzano. Triple arches opened on to a small stream, while curved walls framed the niches on the shorter walls. The plan of Bramante's nymphaeum and its intention as a setting for otium anticipate the garden *loggia* of the Villa Madama. More importantly he had exploited the length and slope of the Belvedere, which might have seemed disadvantages to a lesser architect, with ramps, steps, fountains and trees in a way which Raphael developed in the Villa Madama.

Although the garden *loggia* was completed after Raphael's death the rich combination of stucco and fresco was developed from his decoration of the Vatican *logge*. The Cardinal felt that 'Old testament stories should be limited to the *loggia* of our Lordship.' Giovanni da Udine, Giulio Romano and Peruzzi therefore devised a combination of love-scenes from Ovid with more serious subject-matter, represented by the four elements. This became the standard form of villa decoration, although the combination varied according to the taste of patron and artist. Giulio Romano's emphasis upon the erotic in the Sala di Psyche at the Palazzo del Tè stands at one end of the spectrum, Veronese's great cycle for the Barbaro brothers at Maser at the opposite. Serlio published a two-storeyed version of the garden *loggia* in the 1530s which, together with his presence in Venice in the later 1520s, was to influence the development of villa design in the Veneto. Later in the century Raphael's ambitious combination of gardens, trees and fountains was taken up in the striking displays in the gardens of Villa d'Este at Tivoli and Villa Lante at Bagnaia near Viterbo.

Drawing of the plan of

Villa Madama no. 314 A

Gabinetto dei Disegni e delle

Stampe degli Uffizi, Florence

PALACE DESIGNS

Raphael's palace designs for Medici followers were equally significant. The street facades of the great Florentine palaces were, with the notable exception of Palazzo Rucellai, simpler than those in Rome. Decorum, therefore, limited the references to the antique in Palazzo Pandolfini, designed, most probably in 1515-16, for a Florentine supporter of Leo X. Raphael combined respect for Florentine tradition with a striking allusion to the Antique in the heavily rusticated doorway and in the alternating pattern of round and triangular pediments above the windows. This simple pattern is enlivened by starting those on the ground floor with a triangular pediment and those above with a round one. In the facade of Palazzo Branconio dell'Aquila, Raphael achieved a rhythmic variation unknown in any earlier Renaissance palace design. This elegant palace in the Borgo, although destroyed in the seventeenth century, was commissioned by another member of the Medici circle, Giovanni Battista Branconio. The columns of the ground floor were not aligned with those of the piano nobile, but with niches, which must have been filled with statues. The accompanying tabernacles frame the windows, where round headed and triangular pediments alternate. Raphael achieved an almost polyphonic relationship with the ground floor, which transcended his classical sources, either the hemi-cycle of Trajan's Forum in Rome or the Porta Borsari in Verona.

The inventive freedom with which Raphael re-interpreted the Antique in the Palazzo Branconio dell'Aquila influenced his greatest pupil, Giulio Romano, in the decoration of the surfaces of the Palazzo del Tè in Mantua in the late 1520s, especially as we see it in the drawings made for Jacopo Strada. Michele SanMichele designed the Palazzo Bevilacqua in Verona in a comparable inventive spirit, most notably in his adaptation of the tabernacles framing the window openings on the Porta Borsari, just down the road from the palace. This approach was continued in Rome in the 1550s in Palazzo Spada and in the summer-house of Pius IV designed by Pirro Ligorio. In this context Vasari's view of Michelangelo's design for the tombs of the new sacristy of S. Lorenzo as the building which freed Renaissance architecture from the straight-jacket of Vitruvian architectural rules needs to be revised. Donatello in his architectural designs and Michelangelo in the plans for the Julius tomb and Sistine Ceiling had begun to work with something of the freedom which Vasari so admired, but this found its first full expression in the Palazzo Branconio dell' Aquila.

The Portrait of Raphael and a Friend, painted three or four years before his death, underlines his status at court, which depends not upon his artistic, but rather his social, skills. Both men are dressed informally as Raphael places his hand on his companion, pointing out of the canvas (at Raphael the artist?) with his oher on his epée. One plausible, but uncertain, identification for the fgure in the foreground is as Giovanni Battista Branconio dell,Aquila (1473-1522), a well-placed follower of the Medici and a close friend of Raphael, for whom he designed a now destroyed palace in the Borgo, already discussed.

Raphael's death at the age of 37 was recognised as a tragedy by his contemporaries whose opinion is recorded in a letter written from Rome to Isabella d'Este at Mantua the day after his death in which she described the sorrow: 'for the loss of the hope of the great things that were expected of him which would have served as an honour to our age'. Even in death, however, Raphael achieved an honour for his age in the decision to be buried in a newly-restored tabernacle in the Pantheon. For this the sculptor Lorenzetto, who had worked to Raphael's designs in the Chigi chapels of S. Maria del Popolo and S. Maria del Pace, designed a monumental statue of the Virgin and Child. For the Middle Ages the Pantheon was the home of demons which had to be exorcised by the Christian dedication to the Virgin; the Renaissance reappraisal of the classical building had begun with Petrarch but a true appreciation of the building took time. In the later Quattrocento, Francesco di Giorgio corrected the proportions of the interior of the Pantheon to fit with his own system in contrast with the more accurate rendering shown in two drawings by Raphael; he must have made further ones as a part of his plan to map Ancient Rome for the two to survive were made before his visit to Rome and based upon a lost prototype. Although he followed his model's mistakes in the articulation of the bay system, the drawings achieve a new accuracy in the understanding of the proportions of the great building that is matched in his decision to be buried there so that the Pantheon now seems the natural resting-place for a distinguished artist.

CHAPTER THREE: RAPHAEL IN ROME

CHAPTER FOUR: RAPHAEL IN ROME
– IN THE SERVICE OF THE POPE

CHAPTER FIVE: RAPHAEL IN ROME – PRIVATE COMMISSIONS

POSTSCRIPT

6 April 1483 Raffaello Sanzio was born in Urbino, the son of Giovanni Santi
and Magia di Nicolo Ciarla.

1 August 1494 Death of Raphael's father Giovanni Santi.

1496 Michelangelo moves to Rome where he produces the *Bacchus* and *Pietà*.

1497 Leonardo da Vinci is working on the *Last Supper* in S. Maria delle Grazie, Milan.

10 December 1500 The contract for the now-destroyed *S. Nicholas of Tolentino* for S. Agostino in Città
di Castello was signed together with Evangelista di Pian di Meleto.

1500 Leonardo returns to Florence where from 1503-05 he worked on the
Battle of Anghiari for the Council Chamber in Palazzo Vecchio.

1501 Michelangelo returns to Florence where he completed the David
by 1504 before beginning the *Battle of Cascina* for Palazzo Vecchio.

1503 Date of the chapel in S. Domenico Città di Castello for which
Raphael painted the Crucifixion (London N.G).

1503 Commission to Pintorricchio for the decoration
of the Piccolomini Library, Siena.

1 October 1504 Giovanna Felicia Feltria della Rovere wrote to Pier Soderini,
Gonfaloniere of Florence, recommending Raphael.

1504 Date of the *Marriage of the Virgin* (Milan) painted for San Francesco,
Città di Castello.

1505 Date of the frescoes in San Severo, Perugia

October 1505 Castiglione takes Raphael's *St. George* (W.N.G.) to Henry VII in England
 as a present from Duke Guidobaldo delle Rovere.

1507 Date of the *Entombment of Christ* (Borghese) painted for S. Francesco,
 Perugia. Raphael is documented in Urbino.

1507 Pope Julius II moves out of the Borgia apartments; there are payments for the
 decoration of the new *stanze* in 1508-09 to a group of artists including Sodoma
 and Lorenzo Lotto.

21 April 1508 Raphael writes to his uncle in Urbino from Florence mentioning
 his work on the *Madonna del Baldacchino* (Florence).

1508 Michelangelo begins the Sistine Ceiling, the first half of which was completed
 by the end of 1510 and which was unveiled in August 1511; the second half
 was finished by 31 October 1512.

4 October 1509 Raphael is nominated to a post in the Papal scriptorium in Rome.

1511 Date of the completion of the *Stanza della Segnatura* under the *Parnassus*
 and *Justice* wall frescoes.

1512-1514 Dates of the *Stanza d'Eliodoro* under the *Mass at Bolsena* and the *Freeing of St. Peter*.

1 April 1514 Raphael is appointed architect of St. Peter's.

1 July 1514 Raphael in a letter to his uncle refers to work on a new stanza,
 presumably the *Stanza dell' Incendio*.

1515 Date inscribed by Dürer on a drawing which Raphael had sent him to 'show him his hand' and which was re-used in the *Battle of Ostia* in the *Stanza dell' Incendio* (Vienna Albertina).

15 June 1515 Payment to Raphael for the ten tapestry cartoons that were to be sent to Pieter van Aelst to weave in Brussels.

1516 The date of the mosaics in the Chigi chapel, S Maria del Popolo, executed by Luigi da Pace from drawings by Raphael.

3 April 1516 Raphael accompanies Bembo and Navagero on an excursion to Tivoli.

December 1516 Final payment for the tapestry cartoons.

19 July 1517 The *Stanza dell' Incendio* is completed.

1 January 1518 The vault of the *Sala di Psyche* in the Farnesina is unveiled.

March 1518 Payment for the *Logge*.

1519	Raphael writes to Leo X deploring the continued damage to the ruins of Rome which he was planning to describe and map.
1 May 1519	Sebastiano del Piombo finishes the *Raising of Lazarus* commissioned by Cardinal Giulio de' Medici together with the *Transfiguration* (Vatican) for the Cathedral of Narbonne.
24 May 1519	The *Logge* are finished.
26 December 1519	Seven of the tapestries woven from Raphael's cartoons were hung in the Sistine Chapel.
6 April 1520	Death of Raphael.
7 April 1520	He is buried in the Pantheon.
7 May 1522	Payment to Giulio Romano for work on the *Transfiguration*.
1523	The *Transfiguration* is displayed in S. Pietro in Montorio.

The literature on Raphael is enormous and the following notes are not intended to be comprehensive but to suggest accessible text which are worth exploring further.

GENERAL

The best general introduction Florence and Rome in this period
is M. Hollingsworth, *Patronage in Renaissance Italy. From 1400
to the Early Sixteenth Century* (London, 1994) and M. Hollingsworth,
Patronage in Sixteenth Century Italy (London, 1996).

The best modern monograph is R. Jones and N. Penny, *Raphael*
(New Haven and London, 1983) and short summing up in E. H. Gombrich,
New Light on Old Masters. Studies in the art of the Renaissance IV (Oxford, 1986).
There are other monographs by Sir J. Pope-Hennessy, *Raphael* (London, 1970),
L. D. and H. Ettlinger, *Raphael* (Oxford, 1989) and K. Oberhuber, *Raphael the
Paintings* (Munich/London, 1999). W. Schöne, *Raphael* (Berlin and Darmstadt,
1958) is valuable for its reconstructions of altars in their original frames. For
catalogues of the paintings consult L. Dussler (trans. S. Cruft), *Raphael: A Critical
Catalogue of his Pictures, Wall Paintings and Tapestries* (London, 1970), although this
will be superseded by the Raphael Project, the first volume of which is J. Meyer
zu Capellen, *Rapahel a Critical Catalogue of His Paintings. I The beginnings in Umbria
and Florence ca. 1500-1508* (Landshut, 2001).

For the drawings O. Fischel, *Raphaels Zeichnungen* (Berlin, 1913-41),
8 vols and was completed by K Oberhuber. It is supplemented by P. Joannides,
The Drawings of Raphael, with a complete Catalogue (Oxford, 1983). For a general
account see F. Ames Lewis, *Raphael as draughtsman*, (New Haven and London,
1986). V Golzio, *Raffaello nei Documenti* (Vatican, 1936, reprint 1971) has now
been replaced by J. Shearman, *Raphael in Early Modern Sources*, 2 vols. (New Haven
and London, 2003)

INTRODUCTION AND EARLY RAPHAEL

N. Penny, 'Raphael's "Madonna dei garofani" Rediscovered',
Burlington Magazine (134, 1992, 67-81)

D. A. Brown, *Raphael in America*
(Exhibition Catalogue, National Gallery of Art, Washington, 1983)

RAPHAEL IN ROME: GENERAL

P. B. Bober & R. Rubinstein, *Renaissance Artists & Antique Sculpture. A Handbook
of Sources* (Oxford, 1986)

R. Cocke, *From Magic to High Fashion. The Classical Tradition and the Renaissance
of Roman Patronage* (Norwich, 1993)

C. L. Stinger, *The Renaissance in Rome* (Bloomington, 1985)

P. Partner, *Renaissance Rome 1500-1559* (Berkeley, 1976).

L. Freiherr von Pastor (trans. F. I. Antrobus), *The History of the Popes*
(London, 1950), esp vols 6 and 8.

M. S. Scherer, *The Marvels of Rome* (London, 1955)
(good introduction to Classical remains in Rome)

J. Seznec, *The Survival of the Pagan Gods* (New York, 1953).

R. Weiss, *The Renaissance Discovery of Classical Antiquity* (Oxford, 1969)

Raphael in Rome: Papal commissions

E.H. Gombrich, *Symbolic Images* (London, 1972)

E. Winternitz, *Musical Instruments and their Symbolism in Western Art* (New Haven and London, 1979)

J. Shearman, *The Vatican Stanze; Functions and Decoration* (British Academy Italian Lecture, 1971).

N. Dacos, *Le Logge di Raffaello* (Rome, 1977).

F. Hartt, *Giulio Romano* (New Haven, 1958), 2 vols.

J. Shearman, *Raphael's Cartoons and the Tapestries for the Sistine Chapel (The Pictures in the Collection of Her Majesty the Queen)* (London, 1972).

S. Fermor, *The Raphael Tapestry Cartoons. Narrative. Decoration. Design* (London, 1996)

RAPHAEL IN ROME: PRIVATE COMMISSIONS

M. Meiss, *The Painter's Choice* (New York, 1976), 203 ff.

D.R. Coffin, *The Villa in the Life of Renaissance Rome* (Princeton, 1979).

C. L. Frommel, *Der Römische Palastbau der Hochrenaissance*
(Römische Forschungen des Bibliotheca Hertziana 21) (Tubingen, 1973), 3 vols.

P. Portoghesi (trans. P. Sanders), *Rome of the Renaissance* (London, 1972).

J. Onians, *Bearers of Meaning. The Classical Orders in Antiquity, the Middle Ages,*
and the Renaissance (Cambridge, 1988)

L. Campbell, *Renaissance Portraiture. European Portrait-Painting in the 14th, 15th*
and 16th Centuries (New Haven and London, 1990)

C. Gould, *Raphael's Portrait of Julius II. The Re-emergence of the Original*
(London, National Gallery, n.d [1970])

INDEX

Raffaello Sanzio

SOLIHULL SIXTH FORM COLLEGE
THE LEARNING CENTRE